GOUROCK TO LARGS COAST

THROUGH TIME

Bill Clark

AMBERLEY PUBLISHING

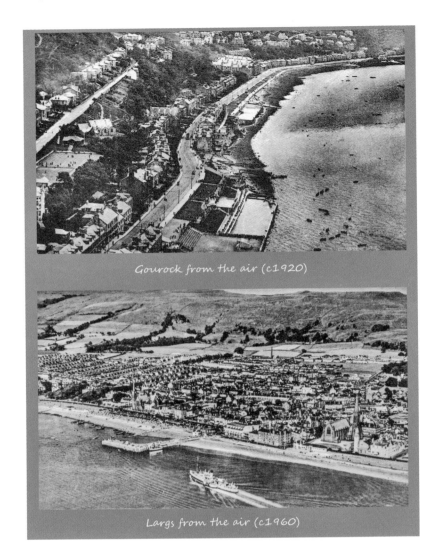

Gourock from the air (c1920)

Largs from the air (c1960)

First published 2013

Amberley Publishing
The Hill, Stroud, Gloucestershire, GL5 4EP
www.amberley-books.com

Copyright © Bill Clark, 2013

The right of Bill Clark to be identified as the
Author of this work has been asserted in accordance with
the Copyrights, Designs and Patents Act 1988.

ISBN 978 1 4456 2308 5 (print)
ISBN 978 1 4456 2313 9 (ebook)

British Library Cataloguing in Publication Data.
A catalogue record for this book is available from the
British Library.

Typesetting by Amberley Publishing.
Printed in Great Britain.

Introduction

The section of coast dealt with in this book is short: the distance from Gourock's eastern boundary at Cardwell Bay to 'The Pencil' memorial just south of Largs, is a mere 16 miles. The road that tracks the land's edge between these two points, however, allows the traveller to experience one of the finest scenic journeys in the land.

Gourock lies at the point where the Firth of Clyde turns abruptly south, as if pouring over a cliff edge in great haste to reach the open ocean. From this point on, as the vista south to Bute and Arran opens up, land, sea and air seem to expand in synchrony, attributing an unparalleled ambience and atmosphere as we travel the road to Largs.

In geological terms, this stretch of coast is a classic raised beach, drained of its waters by Caledonia's continuing slow rise, following its relief from the pressure of the massive glacial overburden that melted away at the end of the last ice age. The road that links the counties of Renfrewshire and Ayrshire lies along this ancient beach, balancing on the water's edge for almost its entire length, except for brief inland forays around Lunderston Bay and Wemyss Point. In some places, the land's emergence from the sea is only marginal, such that the road is almost denied passage by former sea-cliffs, wave-lashed but a moment ago on a planetary timescale. Indeed, wave-lashed still, on occasion, when severe storms blowing in from the west coincide with high water. Roads elsewhere in Scotland have snow gates; the Largs road is unusual in that it has storm gates.

This lack of co-operation on the part of the land is offset to some extent by the nature of its sandstone and conglomerate constituents, which are easily worked, and their use in the construction of many of the buildings found throughout the local area may readily be recognised. This 'Old Red Sandstone' is an ancient rock laid down in Devonian seas, over 350 million years ago. For Lower Skelmorlie, this narrow coastal shelf denies the settlement any potential for expansion and several of its buildings crouch beneath looming rocky crags. The suggestion has been made that Skelmorlie may mean 'in the lee of the great rock'. However, this derivation, although it does seem appropriate, appears to be rather tenuous.

This eastern, or 'lowland', side of the firth inevitably will be compared with the more rugged 'highland' side, where the Argyll hills begin their rise into the western sky. This less wild shore, however, has the advantage of providing a perfect vantage point from which to experience the impressive views north and west towards these hills. From here, the scenes may be at their most spectacular when the westering sun spills its warm, multi-hued light across the skies above the Cowal peninsula and the Isles of Bute and Arran.

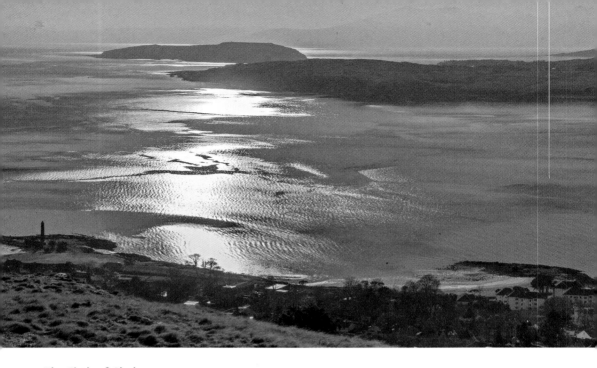

The Firth of Clyde
Seen from the slopes above Largs, afternoon light shimmers on the stretch of water between the Cumbraes and the mainland, known as the Fairlie Roads. 'The Pencil' is visible bottom-left and in the distance, softened by haze, lies the Isle of Arran.

Change can only be illustrated, of course, in the works of humanity, as the grandeur of the landscape, from a human perspective, is apparently constant. The unchanging beauty of the Firth of Clyde can serve, therefore, only to provide a supporting role as a backdrop within some of the images used to portray changes that have taken place in the settlements along this short but picturesque section of coastline.

It has not been possible to produce a comprehensive record of change, because only a random subset of photographs has survived from the past. This book, therefore, can cover only what is available and the early images date from a variety of times, from the 1900s to the 1960s. The later images have been included so that people may relate to 'remembered' places. The format employed tries to pair each old image with its present-day equivalent. Inevitably, finding the exact original viewpoint was not always possible, so some 'proximity licence' has had to be used on occasion.

As the major centres of population, Gourock and Largs contribute a greater percentage of the image pairs used, but the smaller places that lie between – Inverkip, Wemyss Bay and Skelmorlie – have not been forgotten. The history of all of these places has been well recorded, so since this book embarks on what is essentially a photographic quest, only passing reference will be made to dates and events, if appropriate and where space permits.

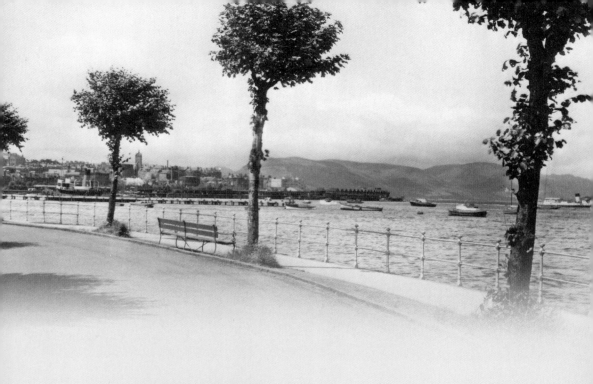

CHAPTER 1

Gourock

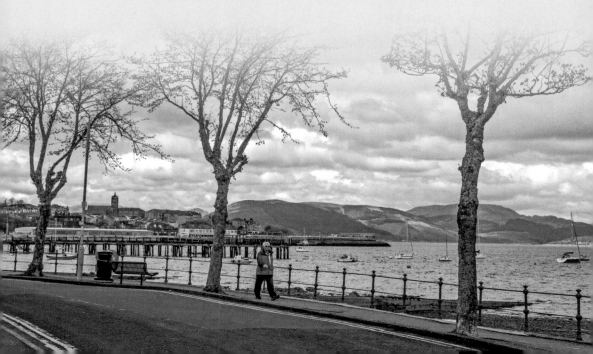

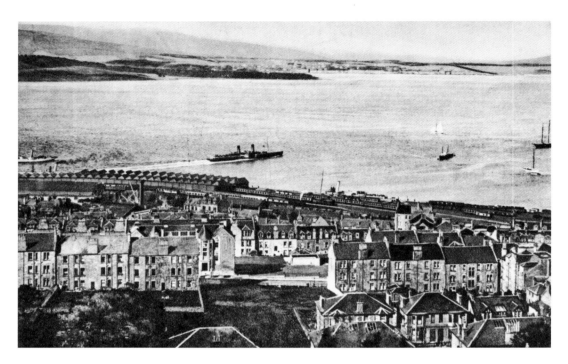

From Tower Hill

Views towards the pierhead from Tower Hill were once unobstructed. Today, however, the slopes are clothed in dense vegetation, above which rows of terraced housing are only just visible. In an early picture, not only these dwellings but also those on closer streets, invisible today, can be seen clearly. Also visible is the long curve of the original station concourse, now demolished.

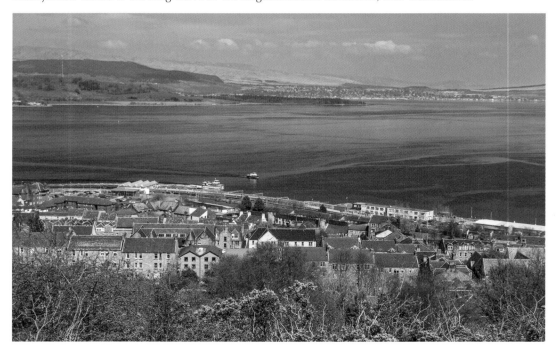

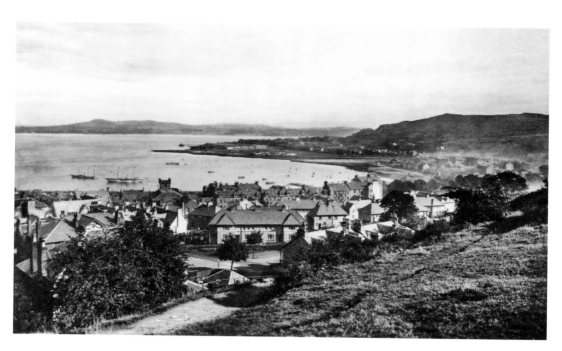

Cardwell Bay

In an early twentieth-century view from Tower Hill, there is little development around Cardwell Bay or on the slopes below Lyle Hill. Today's view, in contrast, shows large areas are now covered with housing. Tower Hill itself has also changed and the original viewpoint behind Broomberry Drive is now blocked by heavy vegetation, so the present-day picture has had to be taken from a higher elevation.

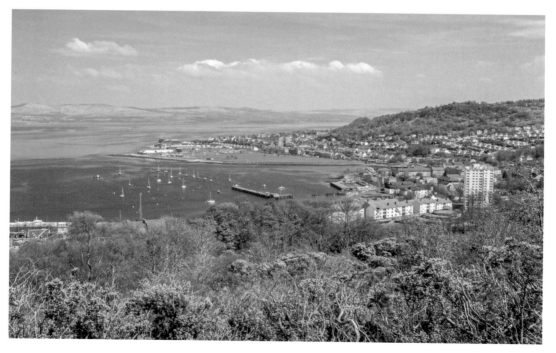

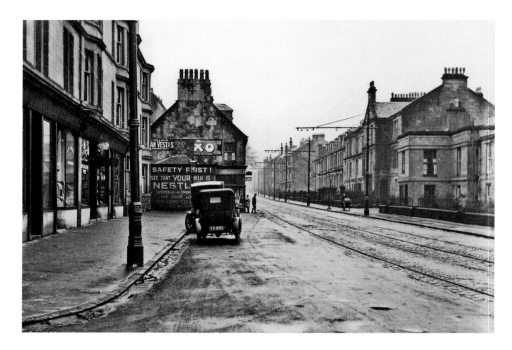

Cardwell Road

A 1920s view, looking west from just beyond the Greenock–Gourock boundary, shows the gable end of a row of houses. These 'Bay Houses' had been built at the start of the nineteenth century as fashionable residences for visiting ministers and professors from Glasgow. By 1880, they were referred to as 'Irish Row', and even later became known as 'Wee Dublin'. Today, no trace remains.

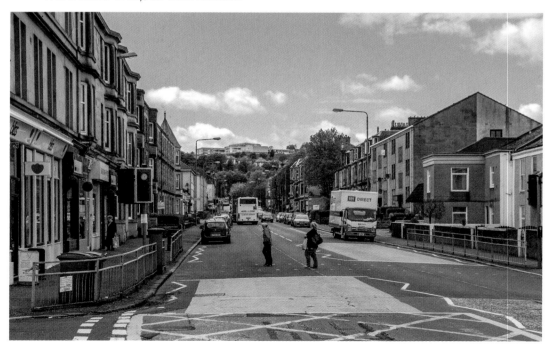

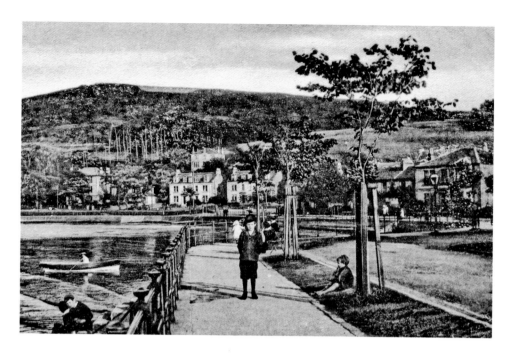

Cardwell Bay Esplanade

To prevent the continual erosion of the foreshore, plans were prepared for esplanades at Gourock in 1896. The walkway at Cardwell Bay (then known as the East Bay) opened in September 1899. An early picture, probably dating from around 1910, looks east towards the Lyle Hill, where the retaining wall for the viewpoint appears to have been recently built. Extensive housing now covers the once bare hillside. Heather, a helpful young lady who happened to be passing, agreed to play the part of the figure in the original.

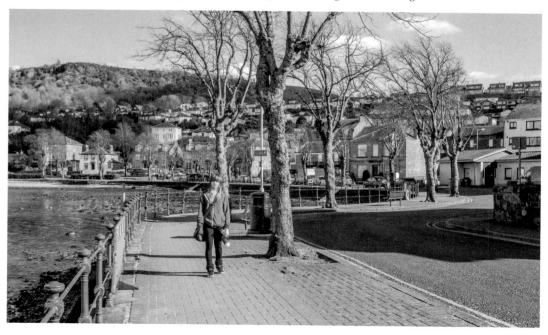

Cove Road

Since this no longer extends as far as it once did, only by using an ultra-wide lens can an approximate equivalent view of a picture from Victorian times be achieved. This is now impossible to repeat, as the road ends roughly at the slipway seen in the mid-distance of the early view. An element common to both pictures is the platform where a children's play area now stands.

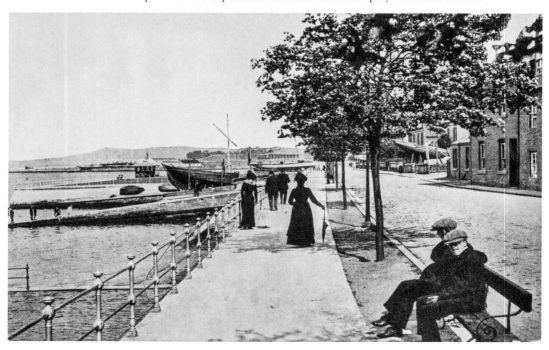

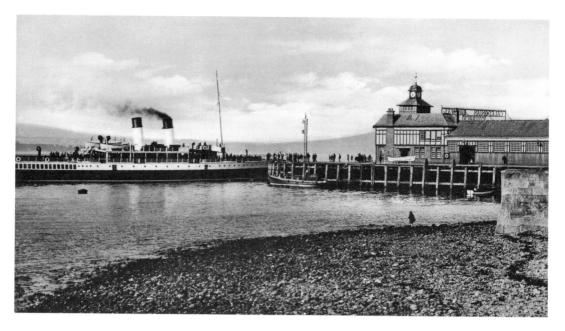

Gourock Station

This opened in 1889, when the Caledonian Railway was forced to extend its Greenock line to compete with the Glasgow & South Western Railway's Princes Pier service, which provided a better connection to the Clyde steamers. Modifications to the station began in the 1980s and the last vestiges of the original, with its long, curving concourse of cast iron, supporting glazed canopies, have been swept away. After much wrangling about development of the site, finally a new station came into use in 2010, but this has been moved back, so where the steamer quay and clock tower once stood is now desolate empty space.

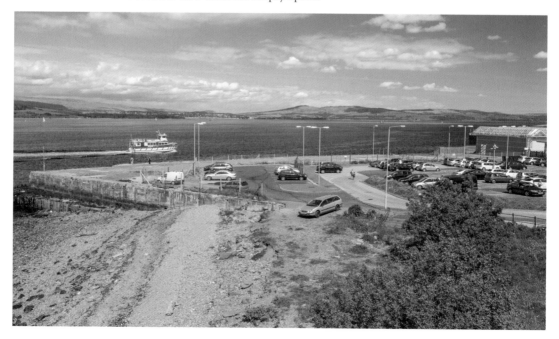

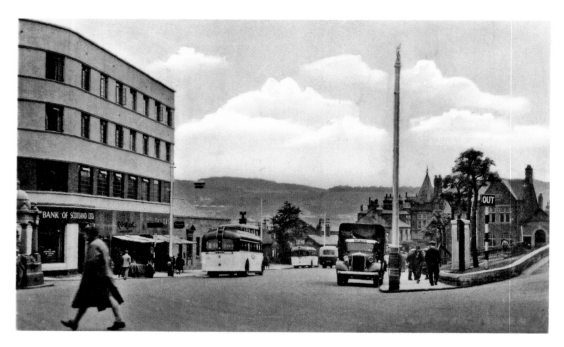

Shore Street

This early picture must date to around 1940, as the Bay Hotel opened in 1938, and the McPherson Fountain, part of which is visible on the left, was removed during the Second World War. Where the hotel and a row of commercial premises once stood (Bank of Scotland, R. S. McColl, Taylor's and the post office) there is now only open space, given over to the motor car.

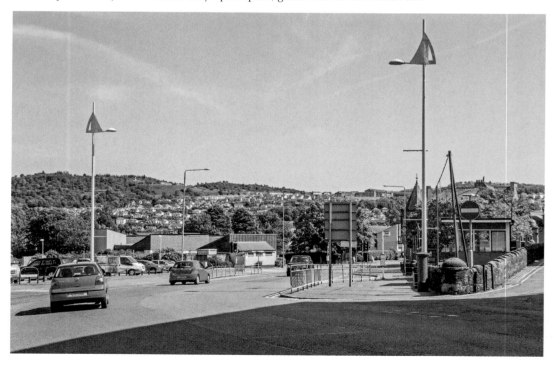

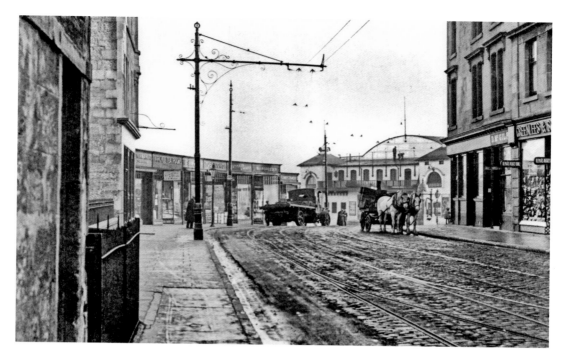

Kempock Street/Shore Street Junction

The building at the pierhead in this early view was known as the Kursaal. This was built as a skating rink in 1908 and the picture seems to date to around that time. The Kursaal has later replaced by the Bay Hotel, which is now also gone, along with the row of shops on the left, so a modern view looking east shows nothing but open space.

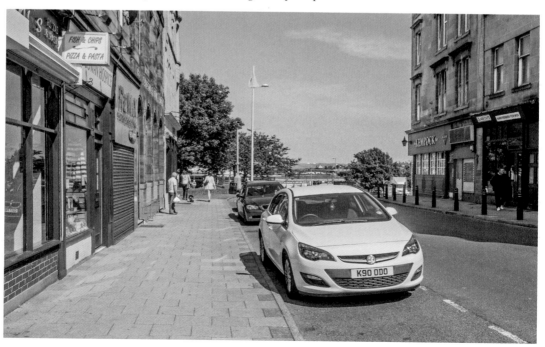

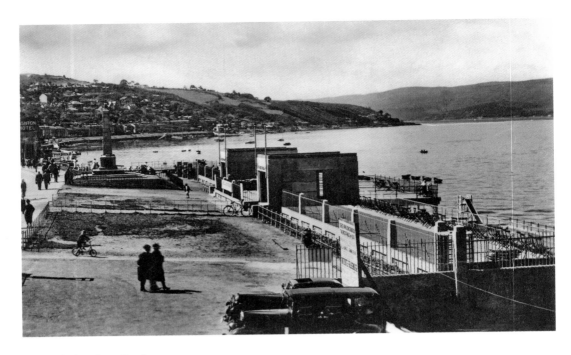

Gourock Outdoor Pool

The original bathing pavilion had been opened in 1912, three years after the tidal lido. However, the distinctive twinned façade, shown in a picture that was probably taken around 1950, dates to a rebuilding that took place in 1935. This is 'the original style' that was retained in the major refurbishment of 2012, which cost nearly £2 million. Shown on a sunny day, as the *Waverley* passes, this is the older of only two heated outdoor pools in Scotland. *Inset*: From the other side in 1956.

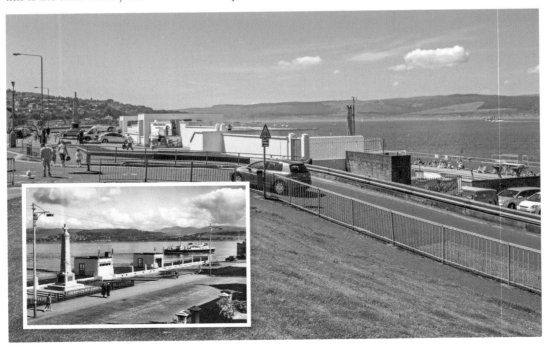

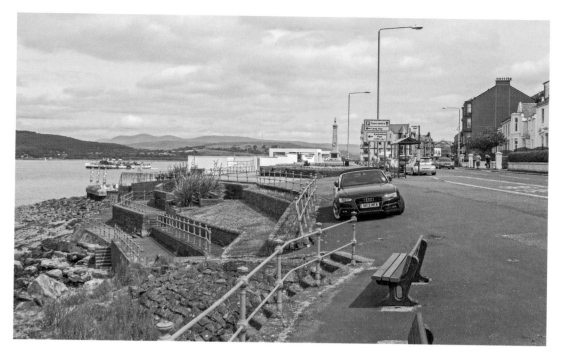

Albert Road/Bathing Station

It is not possible to repeat a modern view from the same elevation, as the boating station from where the original was taken no longer exists. All that remains today are the steps that once led down towards the bathing pavilion. This early picture must have been taken before the First World War, since no war memorial is present. Incredibly, the paddle steamer in the original is echoed, a century later, by its last seagoing relative, the *Waverley*.

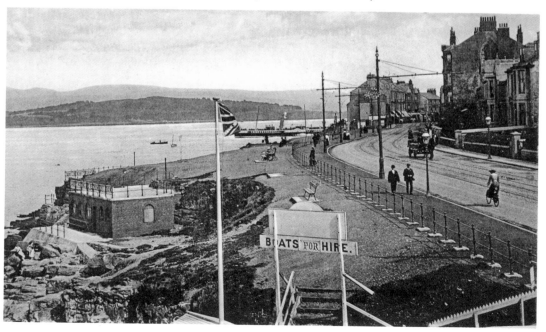

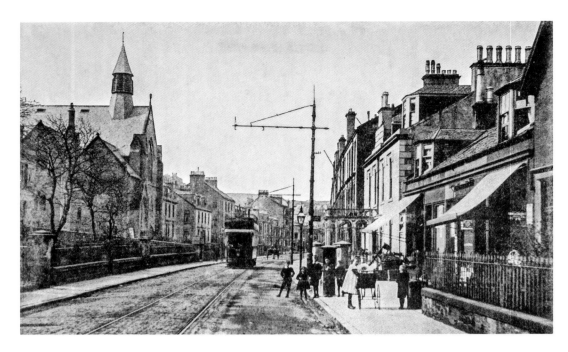

Albert Road

Several buildings in an early view looking west no longer exist. This is dated to before 1923 by Ashton church, which was destroyed by fire that year. Even its successor is now gone and has been replaced by a block of flats. On the right, the Ashton Hotel and the adjacent building have also passed into history, but the gabled building just visible on the right of the original seems to have survived, though its front garden has not.

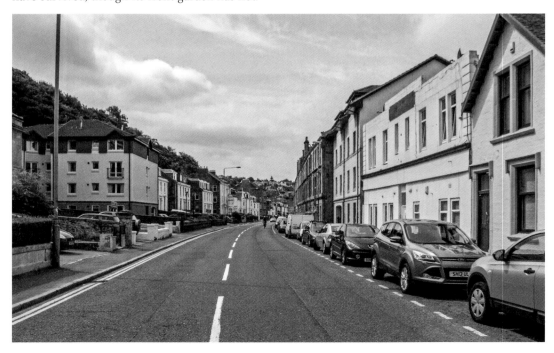

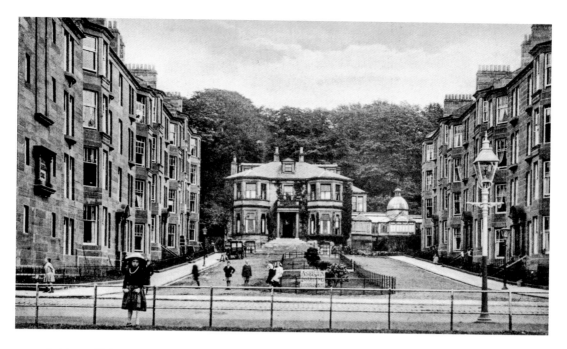

Ashburn Gate

The above picture, believed to date from 1902, shows the 'Ashburn Boarding Establishment', formerly the mansion house of the Gamble family. In the 1930s, this boarding house became the Queen's Hotel, but now serves as a residential home for the elderly. But for the removal of some chimneys, the cul-de-sac is little changed, though the gardens have become a car park and building has taken place on the hill behind.

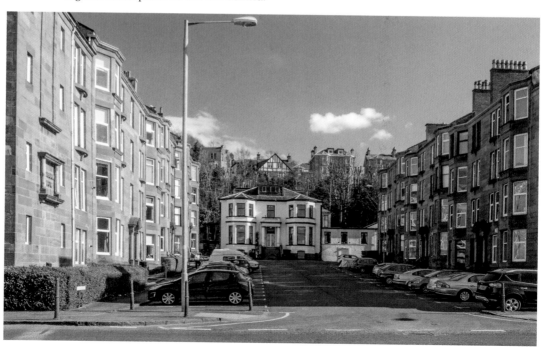

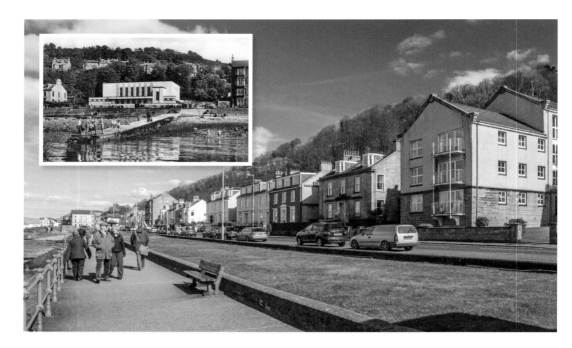

Ashton

Large sections of the seafront survive almost unaltered. There are, however, some notable exceptions. The block of flats on the right above replaced the Cragburn Pavilion, part of which is visible in a picture (*below*) that probably dates from around 1950. Cragburn had been built in the 1930s as a theatre, but was converted first to a cinema and later to a dance hall. By the 1990s, it had fallen into decline, so the local council sold the land for redevelopment and the building was demolished. *Inset*: Cragburn pictured shortly after completion.

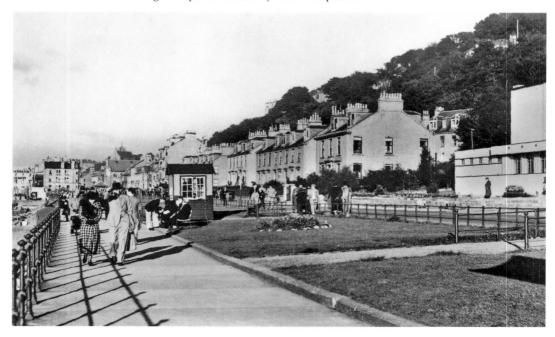

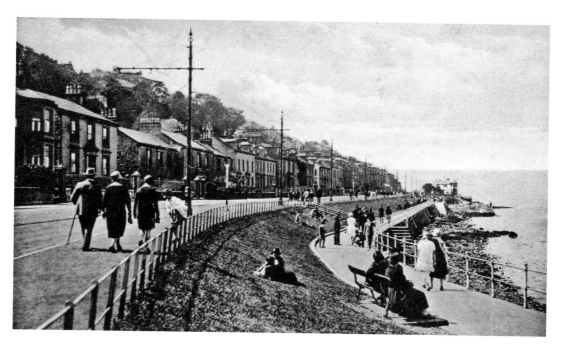

Ashton Promenade Looking West

To combat erosion, an esplanade was opened at the West Bay in May 1900. A picture looking towards the Royal Gourock Yacht Club shows how it looked in the 1920s, as the power grid for the trams dates the view to before 1929, when the tram service was replaced by a bus service. Today, it looks very similar. The same houses line the waterfront and even the seaward railings appear to be original, though the roadside ones have gone.

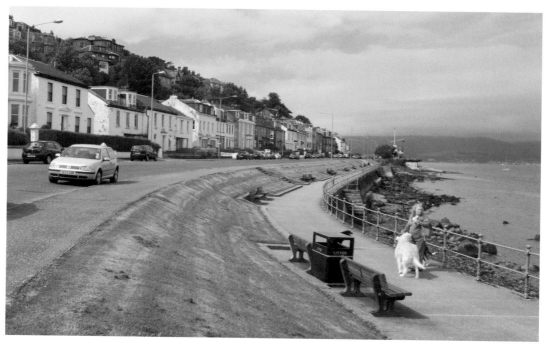

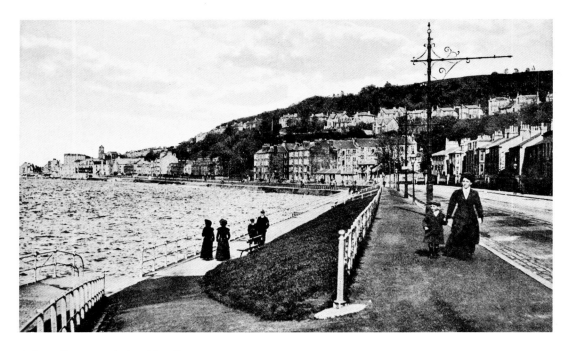

Ashton Promenade Looking East

Power lines for electric trams date this early picture to after 1901 and the style of dress of the people suggests that it may have been taken around 1910. Over 100 years later, fashions have changed and the road where trams used to run is now lined with the ubiquitous motor car. Otherwise, however, except for a new block of flats near the centre, the buildings along the front look very much as they did a century ago.

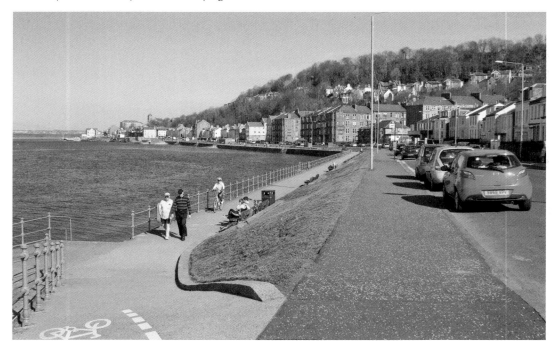

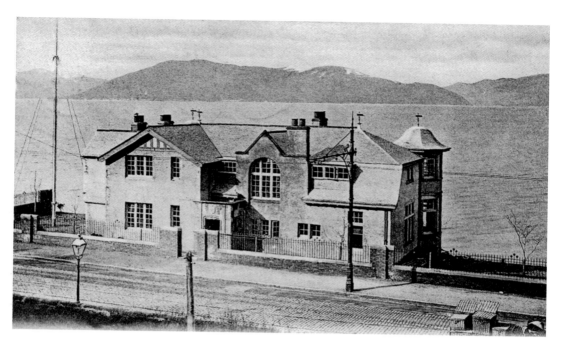

From Victoria Road

Construction of the Royal Gourock Yacht Club was mainly funded by James Coats, owner of the thread mills in Paisley. Official opening took place on 28 February 1903, when the clubhouse looked as it does in the above picture. The original building survives largely unaltered, but for a modified front entrance and the removal of some chimney heads. However, on both sides, extensions have been added – one of which has required the flagpole to be repositioned.

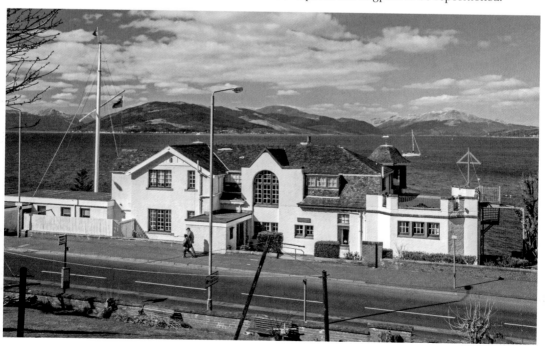

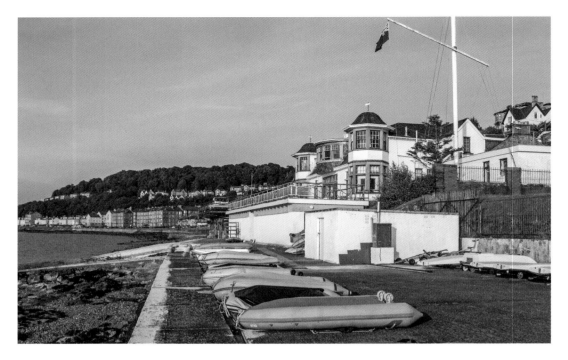

Royal Gourock Yacht Club

Today, the clubhouse sits above a concrete platform and various additions have been made. Comparison with a picture from 1946, however, confirms that the original building itself has changed little. The flagpole has been moved slightly seaward to accommodate the extension visible on the left. The rocks are probably still there, but now buried under several feet of concrete!

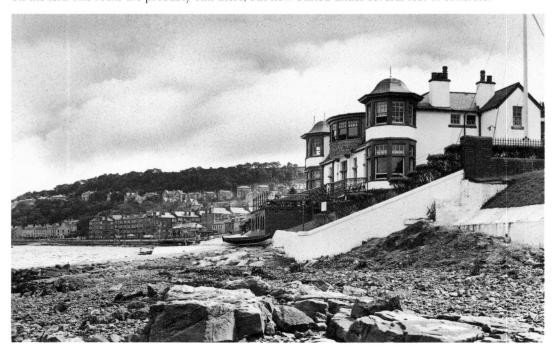

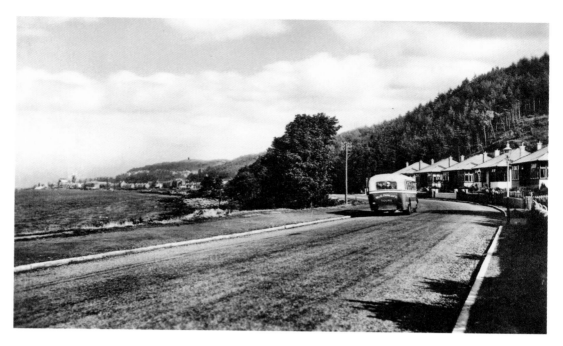

Cloch Road at McInroy's Point

An early picture shows an isolated row of bungalows just to the east of where the Western Ferries terminal is today. This probably dates from the 1940s, as the tour bus belonged to 'W. & R. Dunlop' – a company that went into liquidation in 1949. Today, the houses have been incorporated into an expansion of Gourock along the coast, now extending well beyond this point. A telegraph pole still stands in the same position on the corner but, in the interim, the trees, perhaps even the same ones, have grown considerably.

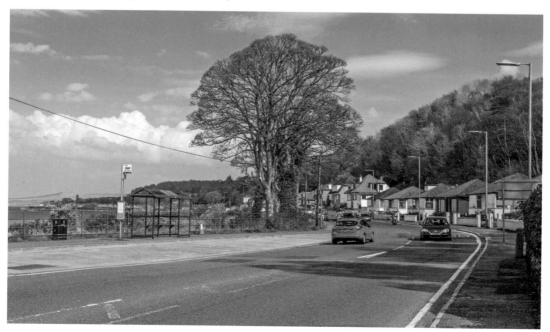

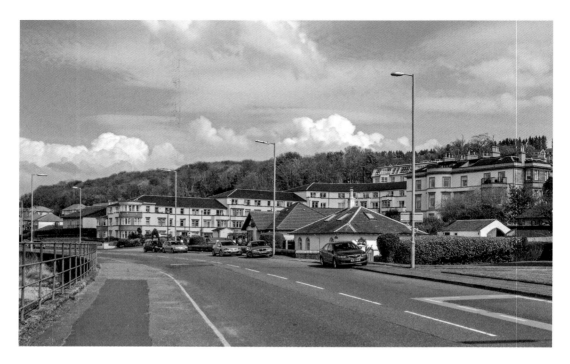

Castle Levan

So much change has taken place in this area that it is difficult to be certain of the original viewpoint. However, the curvature of the roadway at this point on Cloch Road suggests that this present-day view must be fairly well aligned with the earlier view. Though not known for certain, the fashion suggests that this picture may date to the 1930s.

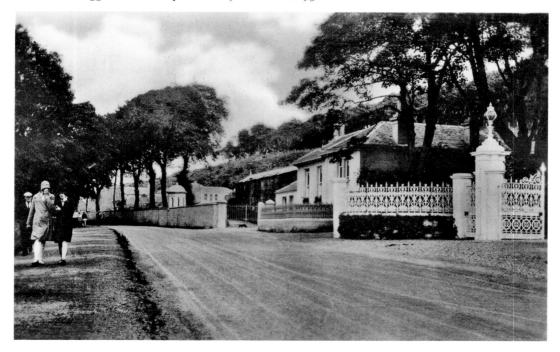

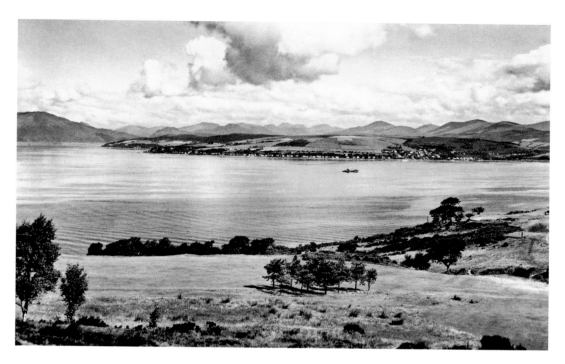

Above Gourock Golf Course

The date of this view is unknown – possibly as early as the 1930s; certainly no later than the 1950s. Today, development on the course itself makes it difficult to identify specific points, so the hills on the far side of the Firth have been used to achieve the approximate width and alignment of the original picture. Pylons and cables that now mar the view from higher up forced a lower elevation for the modern viewpoint.

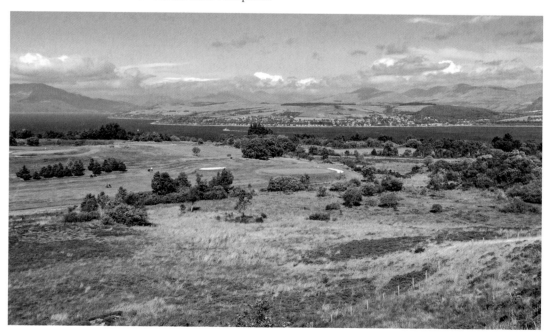

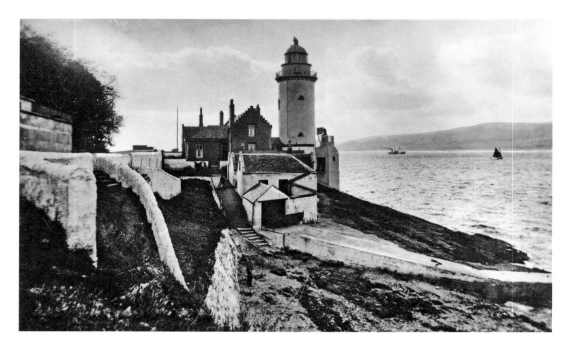

The Cloch Lighthouse

No project dealing with the Clyde coast would be complete without including this well-known landmark. 'The Cloch' (Gaelic for stone) was built in 1797 to warn ships of the dangerous 'Gantocks' skerry and still provides this service today, albeit for a much-reduced marine traffic on the river. The function has now been automated, though the light is now external to the original lantern room, which is no longer used. The lens assembly is now on display in the Museum of Scottish Lighthouses in Fraserburgh.

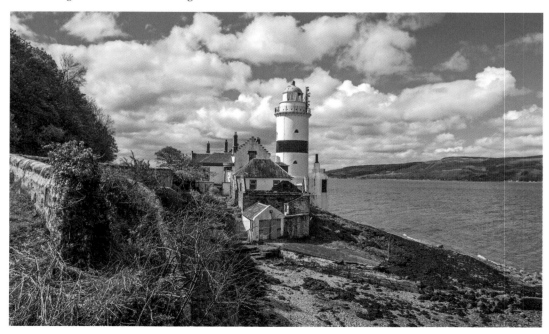

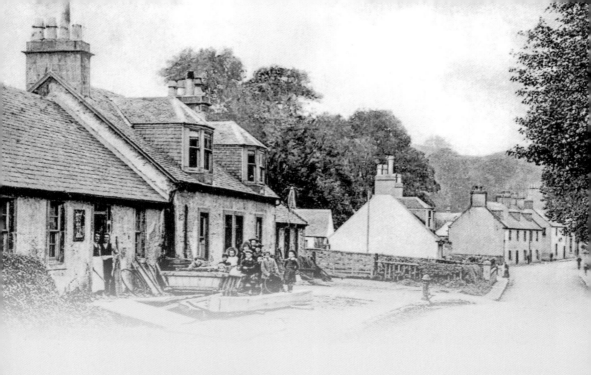

CHAPTER 2

Inverkip

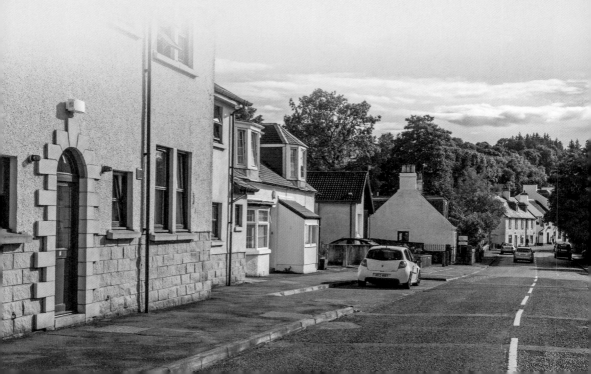

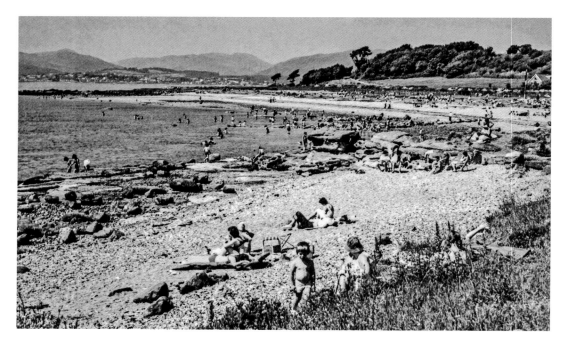

Lunderston Bay

A 1960s view shows that this area was then popular with sunbathers and swimmers. Today, when the sun shines, it is just as popular with day-trippers, and parking nearby can become almost impossible. Even on a really warm day, however, when the present-day picture was taken, the beach never gets as busy as it once did. Few people now take to the water, preferring instead to make use of the adjacent grassed area.

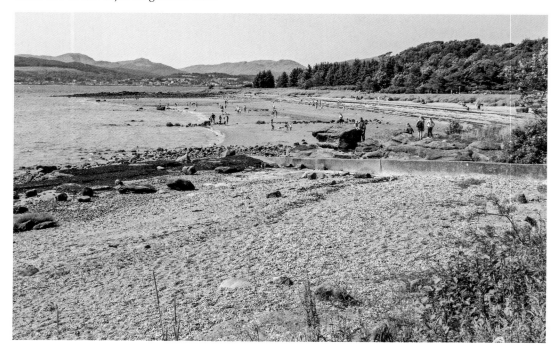

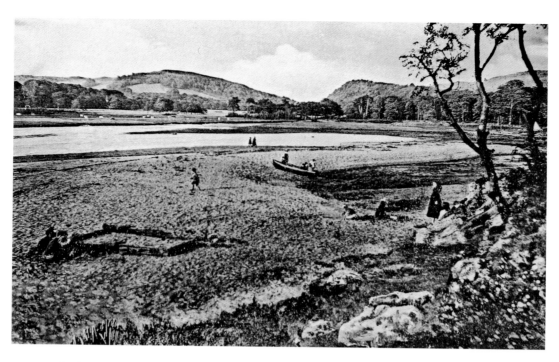

Back Shore

This early view, looking towards where the Kip Water enters the sea, would appear to date from the early years of the twentieth century. Though the foreground area still exists, that on the other side of the burn has long disappeared, to make way for the Kip Marina, which opened in 1973.

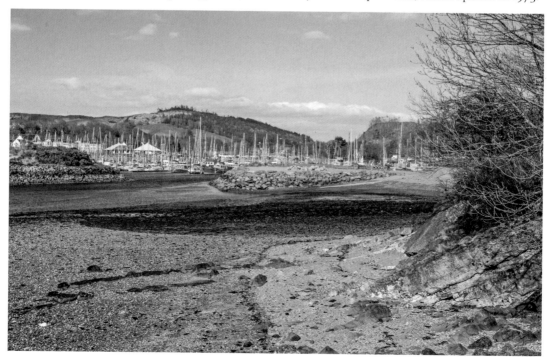

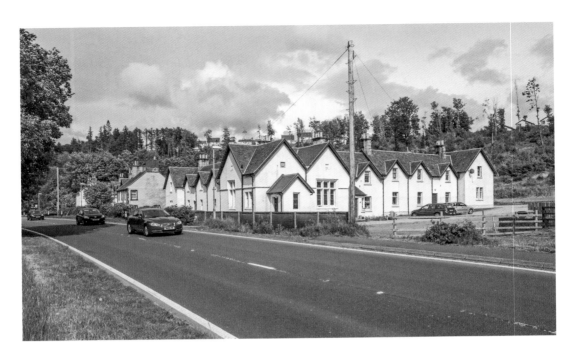

Bridgend Cottages

This landmark block of cottages on the A78 was built originally as accommodation for workers on Ardgowan Estate. It lies a short distance to the north of Inverkip and is within the village conservation area. A picture dating from Victorian times shows that it was once isolated, but houses have now encroached from behind and more building is scheduled on the adjoining area to the right.

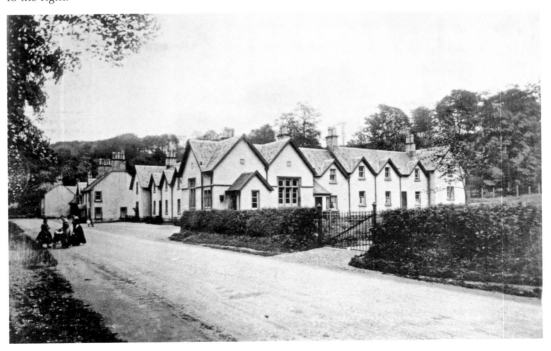

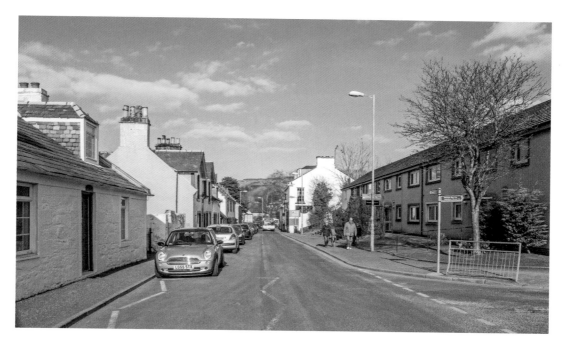

Main Street/Station Avenue Junction

Given its status as a conservation village, much of Inverkip remains intact. The cottages on the left of a present-day view are recognisably those that appear in an early view, probably dating from around 1920. The section on the right, however, between the junction and the Inverkip Hotel, is modern, so the original buildings were presumably demolished before the conservation order came into force.

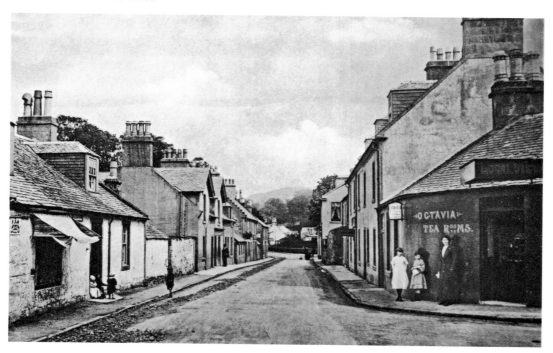

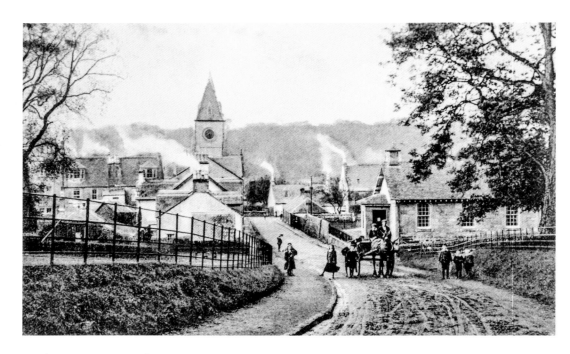

Station Avenue & Road

The date of this early view looking north towards the junction with Main Street is unknown, but it was probably taken in the early years of the twentieth century. Much is now hidden by trees, but the original schoolhouse, built in 1836, still stands, as do the still-chimneyed dwellings opposite. The United Free Church that once stood on the corner of Main Street, however, is gone. In the distance, just visible above the trees, are the masts of yachts on the hard at Inverkip Marina.

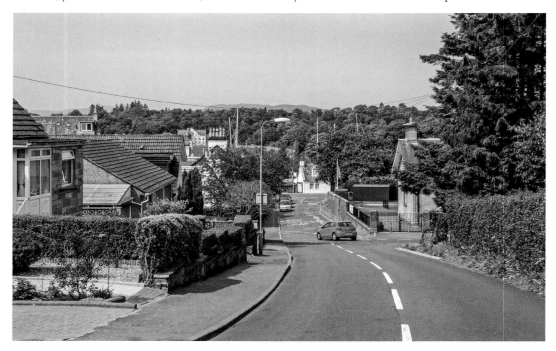

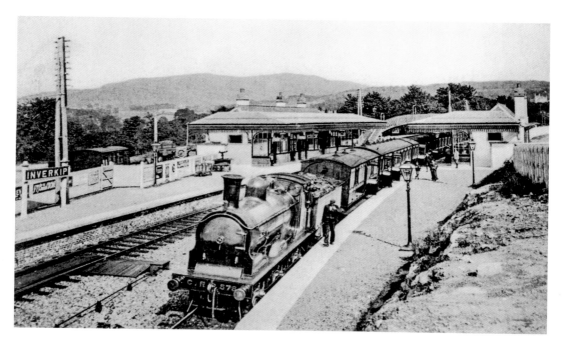

Inverkip Station

This early picture probably dates to around the turn of the last century. The station opened in 1867, two years after the Caledonian railway had extended its line to Wemyss Bay. At that time, there were both an Up and a Down line; today, the line is single track. No longer a secluded rural stop, the station has changed beyond recognition and now sits amid housing.

Looking East Along Main Street

The village has now been declared a conservation area, but some prior changes must already have taken place. A modern view shows many houses that once stood on the left have gone, though the former police station, unfortunately now derelict and decaying, survives on the far left. The right side, however, including the iron railings, looks almost as it did in an early view, probably dating from sometime around 1920.

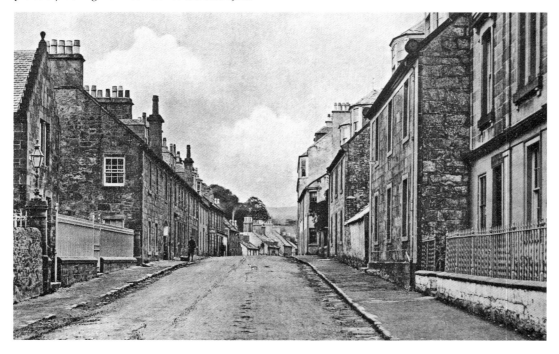

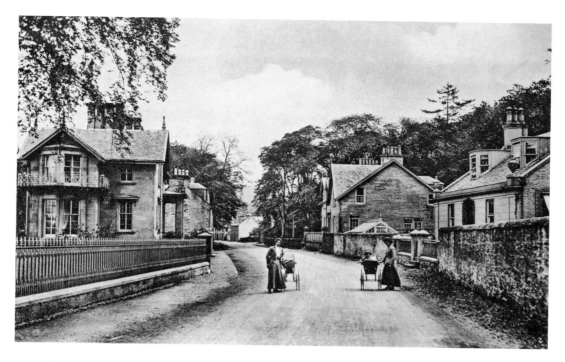

The West End

A picture from the beginning of the twentieth century shows the far western end of the village. About 100 years on, not only do the same houses still stand, but the wall and iron railings also appear to be original. Now cut off by the bypass, this part can be just as peaceful as it once was in Victorian times.

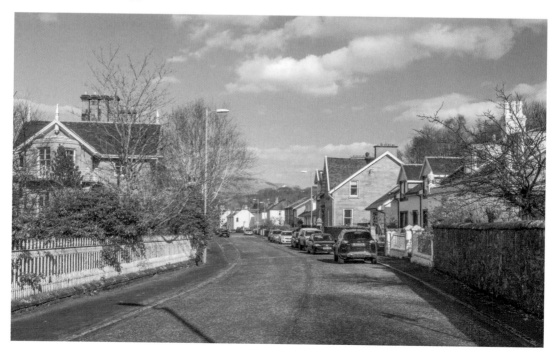

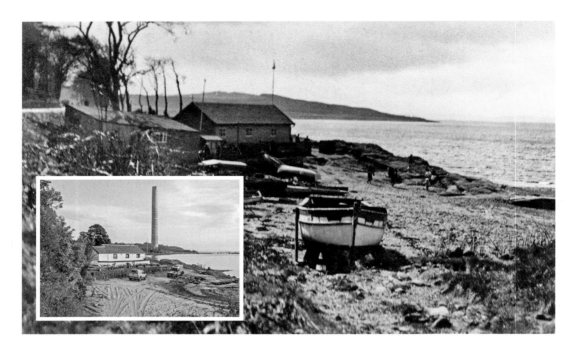

Yacht Club

In a secluded cove to the south of the village lies this small sailing club, pictured in 1935. Other than improvements to the clubhouse, little has changed here, though for the past forty years it has been overshadowed by the power station chimney, recently demolished. *Inset:* View prior to the blow-down on 28 July 2013.

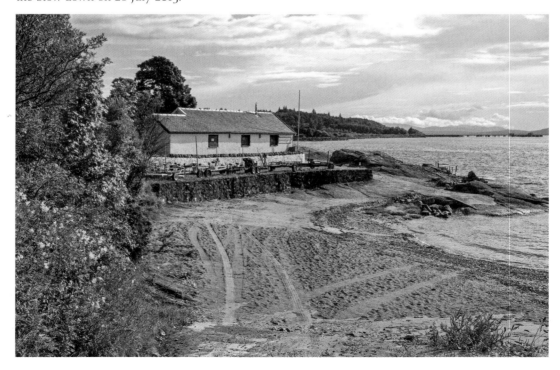

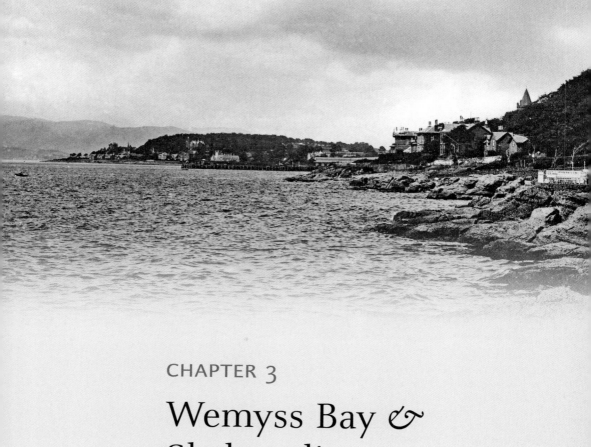

CHAPTER 3

Wemyss Bay & Skelmorlie

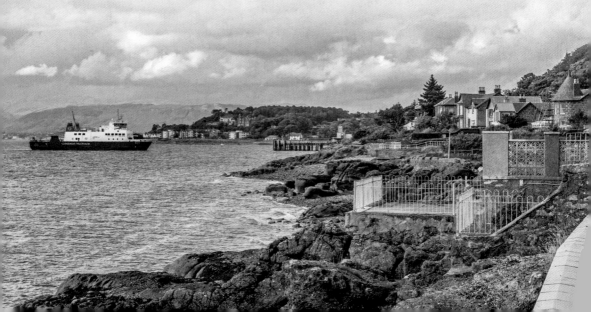

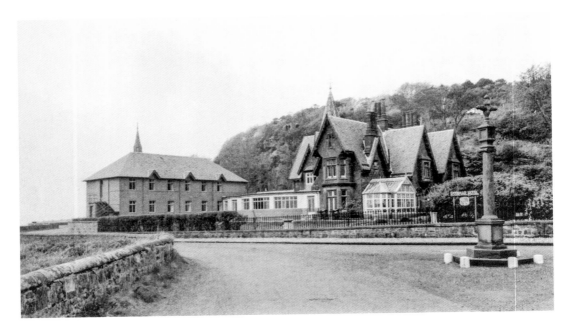

Wemyss Point

With the coming of the railway in 1865, Wemyss Bay began to develop. To the north of the station lay the Wemyss Bay estate, where many of the very rich decided to set up residence and many large villas were built. From there, they could commute to Glasgow and the area became known as 'Little Glasgow'. The villa on this early view was marked on a 1912 map as Rothmar, but by this time it had become the Rothmar Private Hotel. Though some villas have survived, this is not one of them and the location today is unrecognisable. Only by aligning on the wall on the left can the viewpoint be identified.

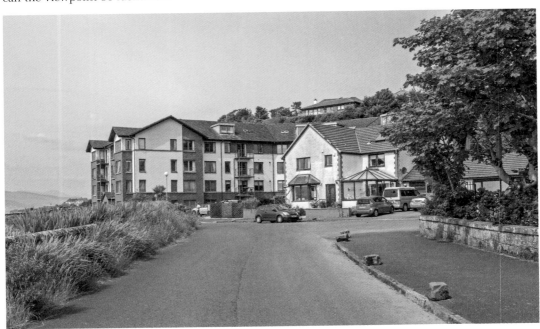

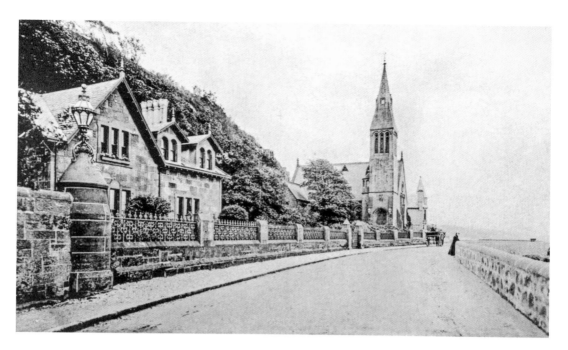

Undercliffe Road

An early picture shows the English Episcopal church that stood on the shore of Wemyss Point. The Wemyss Bay estate had been bought in 1860 by George Burns, who had been one of the founders of the shipping line, Cunard, and whose son, John (later Lord Inverclyde), was chairman of the company. George's wife died in 1877 and he had the church built in her memory. It remained a place of worship until 1956 but has since been demolished. However, the nearby villa survives, allowing the location to be identified.

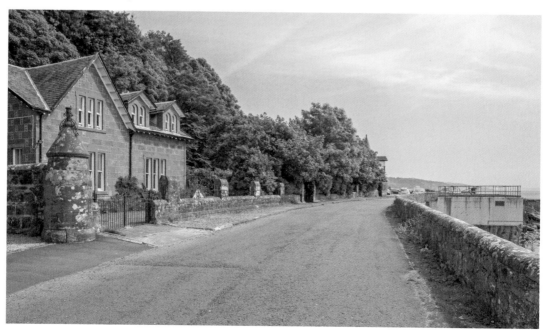

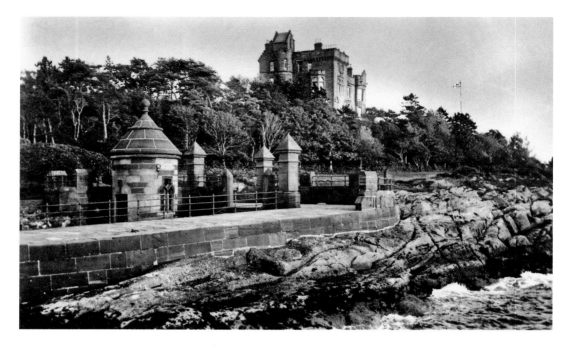

Castle Wemyss

This large mansion house, which stood high on Wemyss Point, was built in 1850 and extensively remodelled in 1860. The estate belonged to the Burns family (Baron Inverclyde), but when the fourth baron died in 1957 it was no longer affordable and was sold. Thereafter, it fell into disrepair and was eventually demolished in 1984. Rezoning of greenbelt allowed development of the site in the 1990s. Today, the jetty, shown in a mid-1930s picture, is the only significant surviving part of the estate. *Inset*: Seen from the landward side.

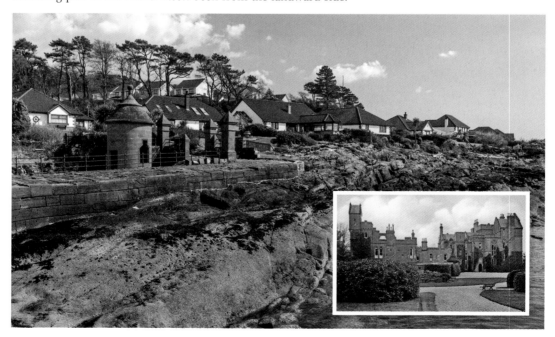

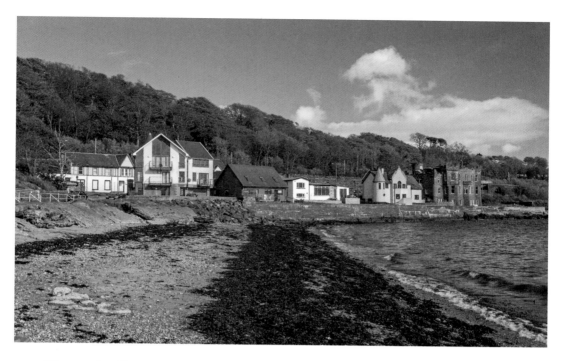

Wemyss Bay Shore

A present-day view of the eastern end of the shore, where Wemyss Bay Road joins the main road, shows mainly modern buildings. Those at the far edges of the picture, however, also appear in an earlier picture dating from the 1960s. The red sandstone building on the right survives, as does the Wemyss Bay Hotel on the left.

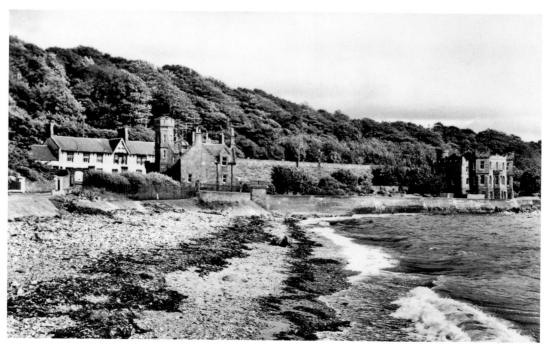

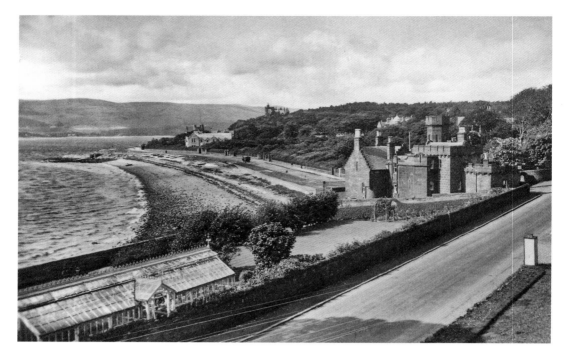

Towards Wemyss Point

This picture of the foreshore along Wemyss Bay Road is believed to date to the 1930s. The foreground short section of road, opposite the Wemyss Bay Hotel, has changed utterly in the interim. Replacing the turreted property on the corner and the garden area, there are now modern dwellings that are devoid of the elegance and character of their predecessors.

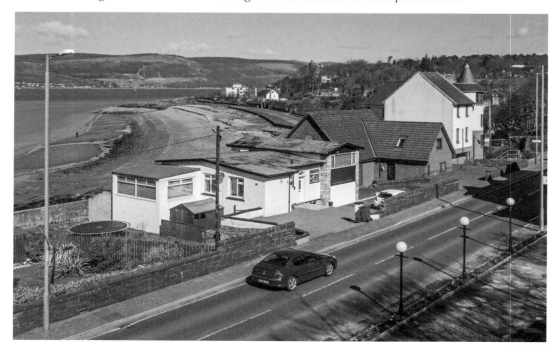

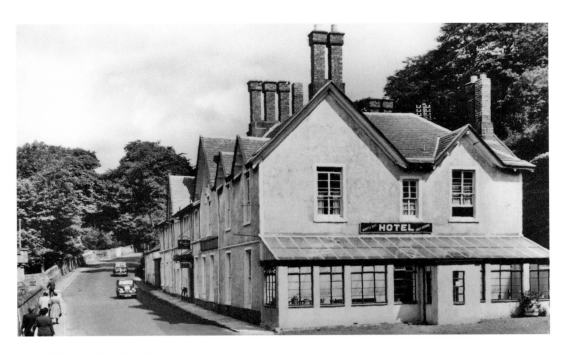

Wemyss Bay Hotel

Located at the convenient halfway point between Greenock and Largs, this began life as a coaching inn and the original stable block still survives to the rear. An early picture appears to date to no later than 1950. Since then, the magnificent chimneys have been removed and some mock Tudor embellishments have been added, perhaps so that the building reflected the style of the nearby station.

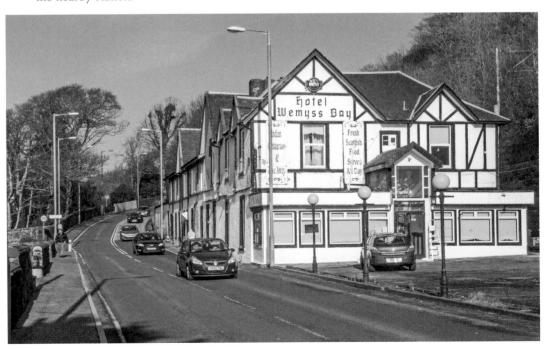

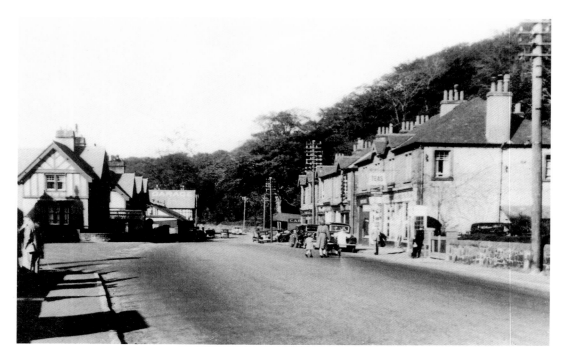

Pierhead/Main Road

This early picture, apparently dating from the 1940s, is captioned 'Station Square'. Today, the square has lost its identity. Now severed from the main road, it has become merely the station car park and holding area for ferry traffic. Otherwise, the architecture of the surrounding area remains essentially unaltered, but for the distant addition, beyond the row of shops, of a car showroom.

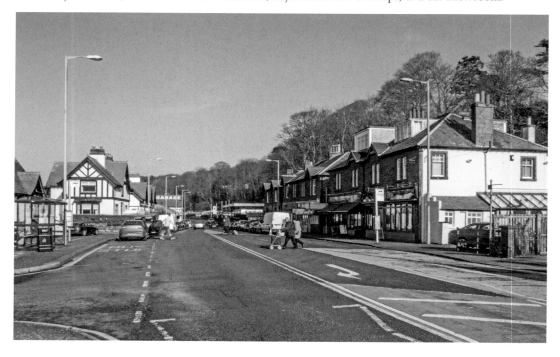

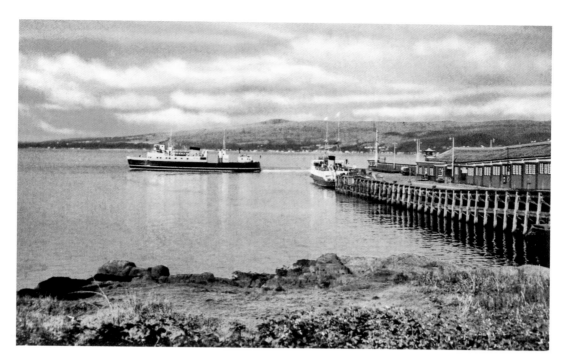

Wemyss Bay Pier

Two earlier nineteenth-century piers had been swept away by storms and the present pier is contemporary with the station – both built in 1903. The pier has been subject to various changes over the years and even the late-1960s version above has been since modified to accommodate the car ferries now operating the service to Rothesay.

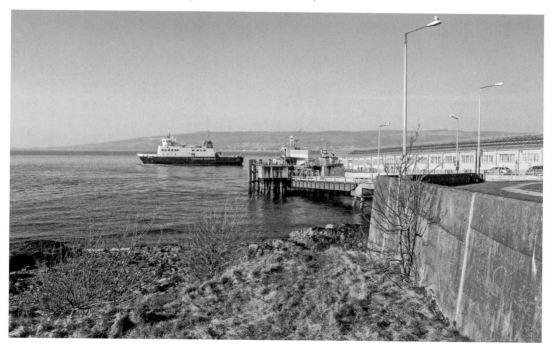

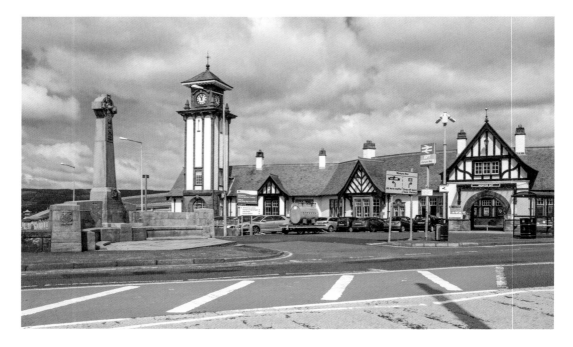

War Memorial/Station Square

Though the railway arrived in Wemyss Bay in 1865, it was not until 1903 that the Caledonian Railway built a new station and adjacent pier for its sister company, the Caledonian Steam Packet Company. Modern clutter of signage and lighting now spoils the once open aspect of the square, seen so clearly in a 1920s picture, but the half-timbered mock Tudor building, with its magnificent 60-foot clock tower, has been restored to its original glory and is arguably the most beautiful station in Britain.

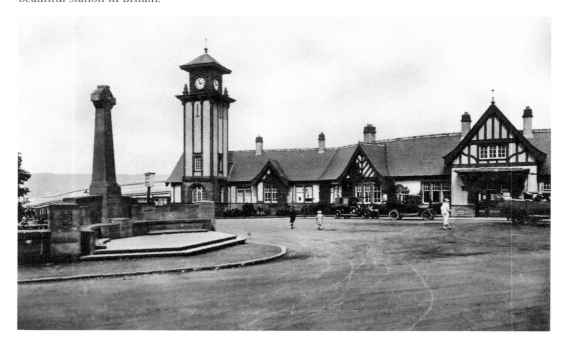

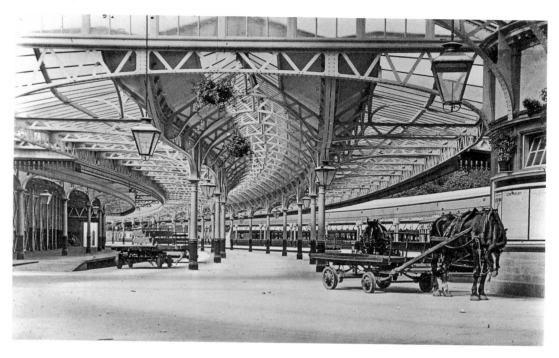

Station Interior

On the inside, the station is no less magnificent, with its ironwork ceiling curving elegantly above a skylit concourse. This is one of the earliest pictures, probably taken not long after it opened in 1903. Today, a passing dog serves as the four-legged equivalent of that long-ago horse. One hundred and ten years on, the station remains impressive, even without its pendulous flower baskets and lamps.

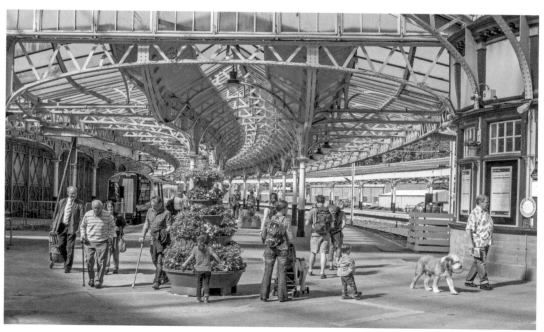

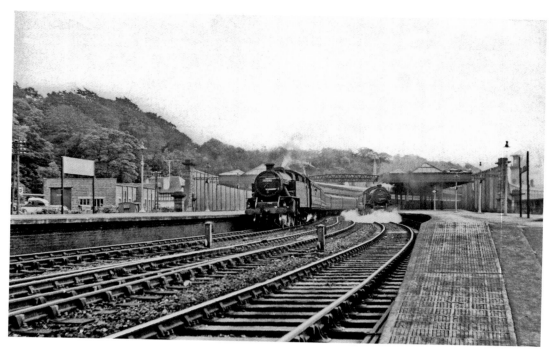

Wemyss Bay Station

A view of the station in 1957, from the outer end, shows (on the left) Class 4P-C 2-6-4 No. 42241 waiting to depart for Glasgow Central. Only one of the three inter-platform lines that once existed now remains, though another line, barely visible at the extreme right, is also still in use today.

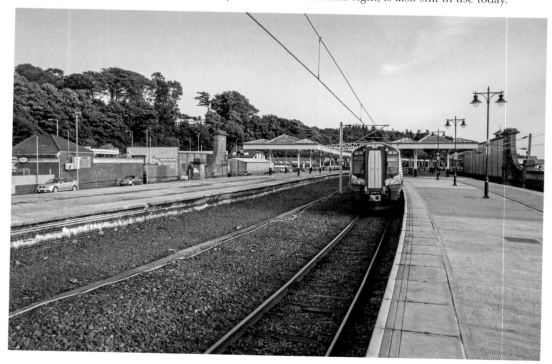

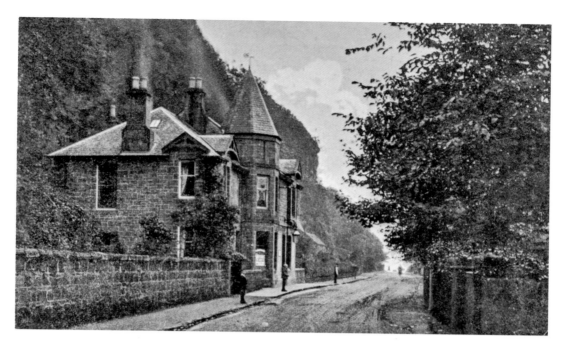

Old Toll House/Post Office

An early view, dating from 1907, shows 'Colinslea', which had been the toll house on the Largs road. At the time this picture was taken, it served as the post office and a grocery store. Today, the red sandstone building still stands close under the cliff and even retains some of its chimneys. The post office, however, is now situated further along Shore Road, on the opposite side, hidden from this angle by the trees on the right.

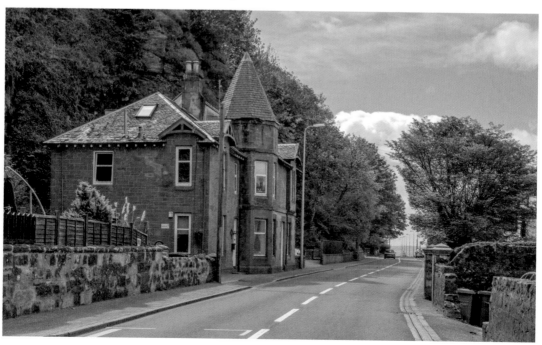

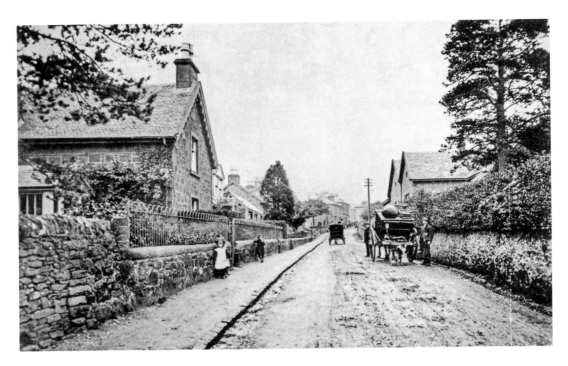

Skelmorlie Castle Road

A view looking east towards the Cross seems to date to the early years of the twentieth century. Around 100 years on, the viewpoint, just above the community centre, may be identified by the buildings on the left, which have survived. Considerable change has taken place on the opposite side, however.

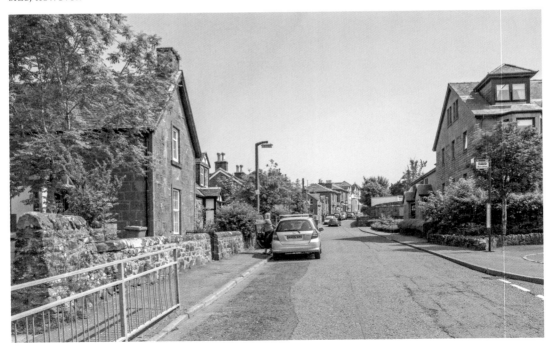

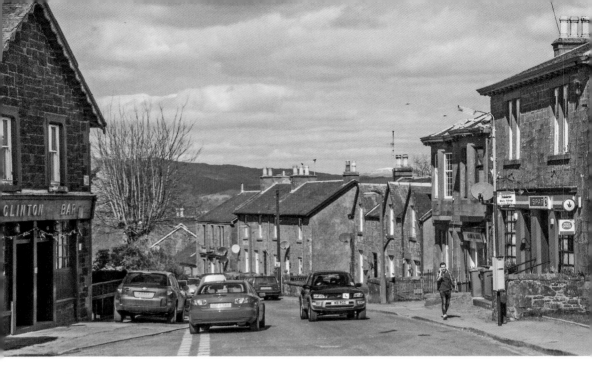

Below the Cross

A present-day view looking down from the Cross, along Skelmorlie Castle Road, reveals that the red sandstone properties visible have almost certainly existed for over a century, since each also appears in an early view that probably dates from before 1920.

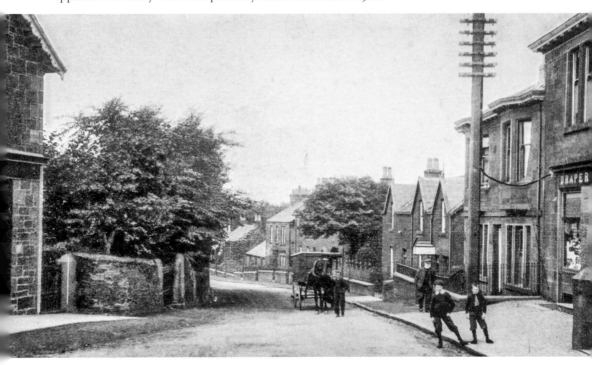

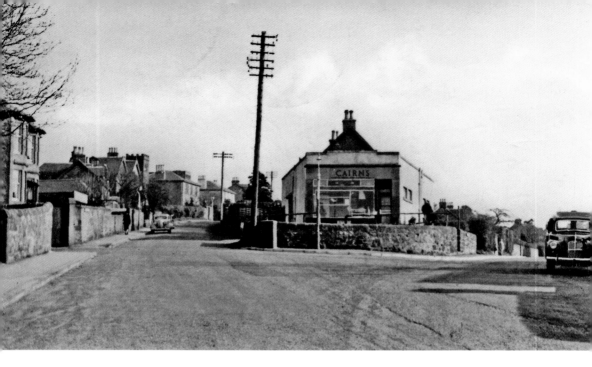

Above the Cross
This view from the Cross, at the junction with Seton Terrace, dates to the mid-1960s. Since then, modern buildings have replaced both the house on the far left and the shop, though the turreted building in the mid-distance has survived.

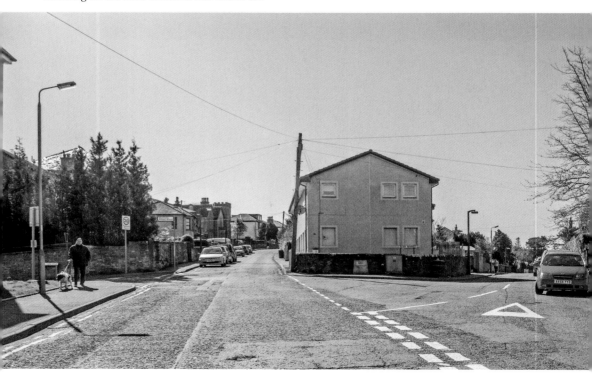

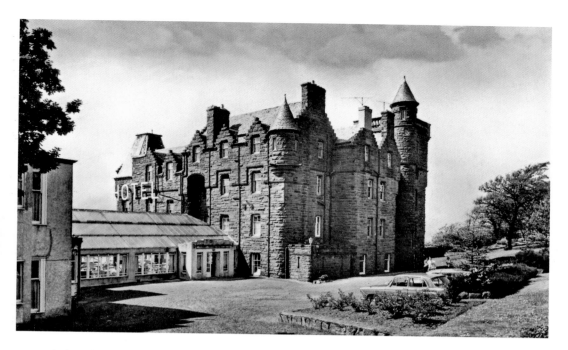

Skelmorlie Hydropathic

This castle-like edifice, built in 1868, occupied what seemed like a precarious position on the edge, giving the impression of being an extension to the cliff itself. It was a landmark from both land and sea, but closed finally in 1984 and was demolished in the 1990s. The area where it stood has become the gardens of the houses along Montgomerie Terrace, as these have been built further back from the cliff's edge. *Inset*: The hotel seen from the north.

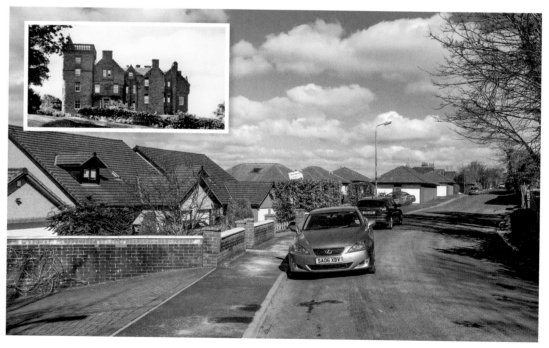

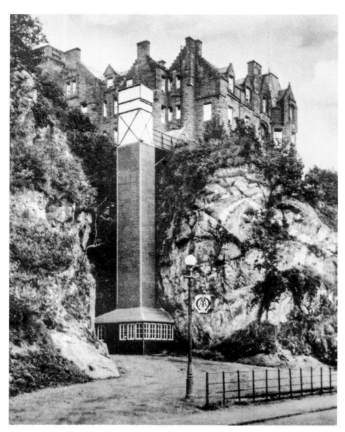

Hydropathic Elevator

In the days when most people did not own a car, many guests arrived by rail and walked from Wemyss Bay station. To circumvent the effort of carrying luggage up the steep hill to the hotel, a lift was installed in a convenient cleft in the cliff face. Not only guests ascended this way, but also seawater, which was piped up to be warmed for the swimming pool. It was constructed in 1941 and remained in use until the 1960s. No trace of it now remains and most people probably have no idea that the turning point across the road from today's post office once held such a device. The early view also illustrates how close to the cliff edge the hotel stood, whereas the houses that replaced it are not visible from the same angle.

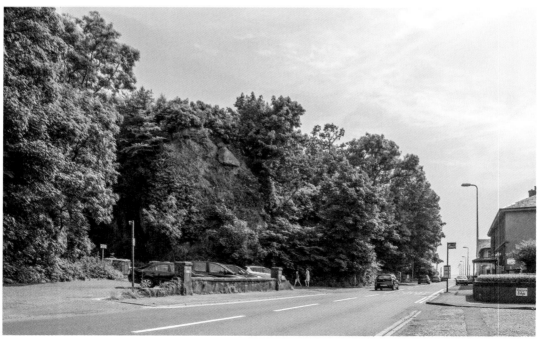

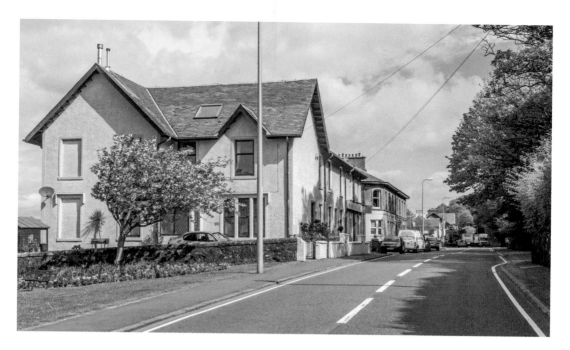

Looking Towards Wemyss Bay

This is the last house that stands on the seaward side between Skelmorlie and Largs. Beyond this point, the road remains 'on edge' for the rest of the way. Though considerably modified, the dwelling survives, along with the others in the block, from an early view. The style of vehicle suggests that this picture was taken around 1930. With modern traffic, taking a position to achieve the same viewing angle was somewhat more risky than it would have been for the original photographer.

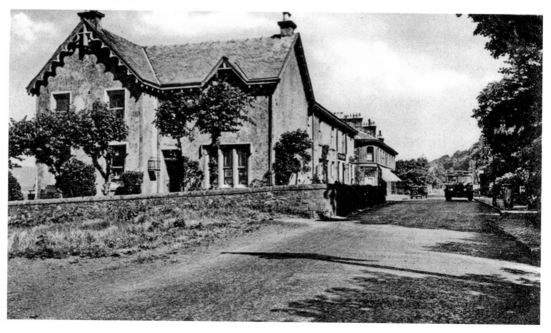

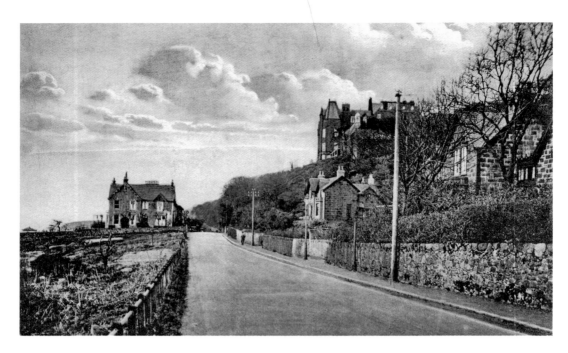

Shore Road

The building in the previous picture is again seen in this view from further south, which also shows the imposing landmark of the Hydropathic Establishment perched 100 feet up, on the cliff edge. Today, the hotel has gone, as has the building on the right, but the house near the centre of the picture survives, now partly obscured by a modern construction. The small structure on the left is an electricity substation.

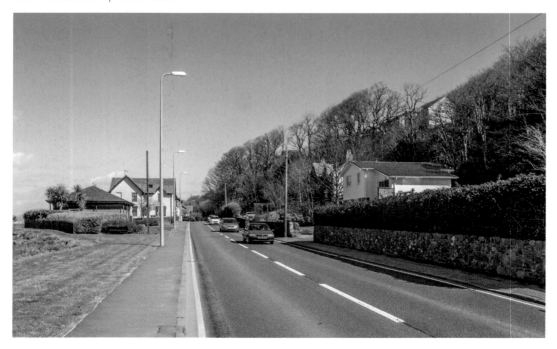

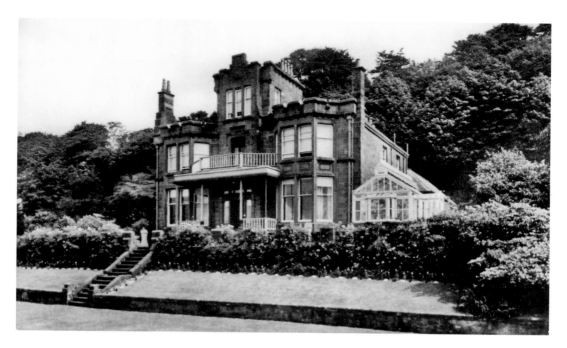

Marine Court Hotel

The road leading south from Skelmorlie once boasted several high-class hotels. Most, such as the Heywood and the Redcliffe, have now gone – replaced by bland, anonymous apartment blocks. One that does survive, however, though no longer functioning as a hotel, is the former Marine Court – once renowned for its musical entertainment. Though bereft of its fine chimneys and now partially decapitated, the building remains recognisable.

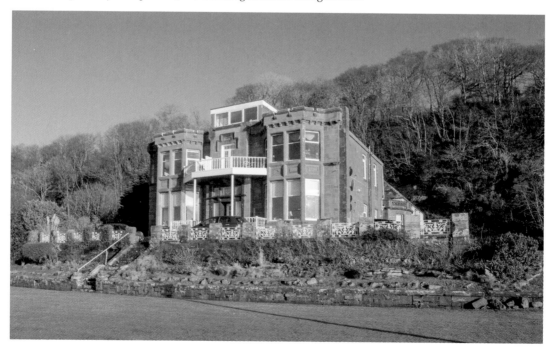

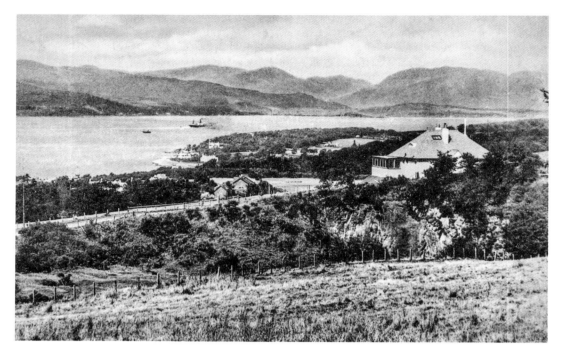

Skelmorlie Golf Course

In the 1940s, from a position behind the clubhouse, this was the view looking across Wemyss Bay towards Dunoon. Today, the view proved impossible to recreate, but a view from slightly lower is roughly equivalent. The nine-hole course that was first established in 1891 became a thirteen-hole course in 1909 and finally, in 1999, it was fully extended to eighteen holes.

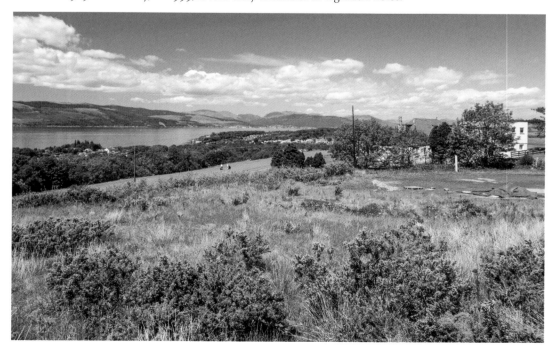

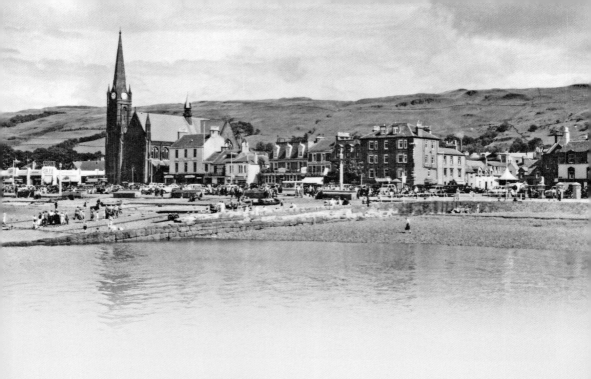

CHAPTER 4

Largs

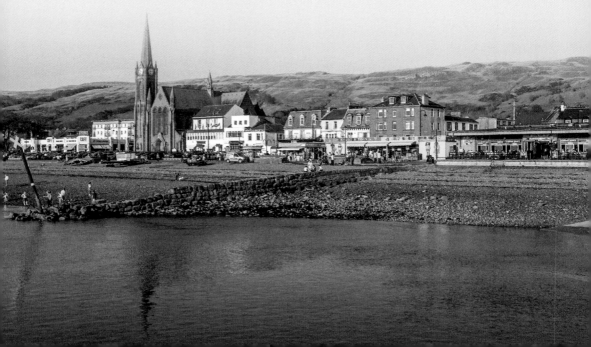

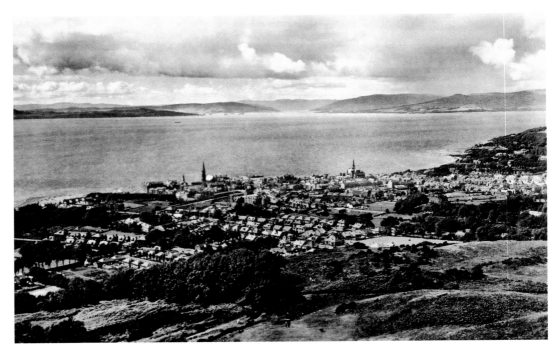

From Above Douglas Park
Largs is believed to take its name from the Gaelic *'learg'* – a hill slope. To the east, the town is surrounded by such slopes, from where there are impressive panoramic views across the Firth. This early view, looking north-west towards the entrance to Loch Striven and the Kyles of Bute, probably dates to the 1950s, since when the town has visibly expanded.

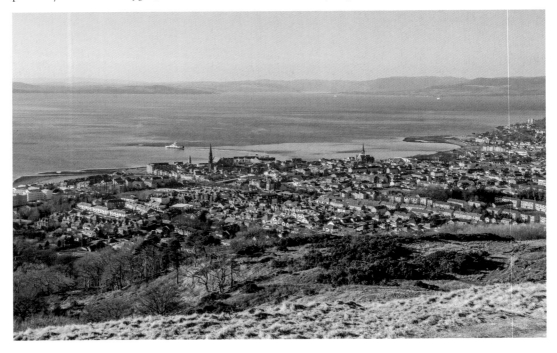

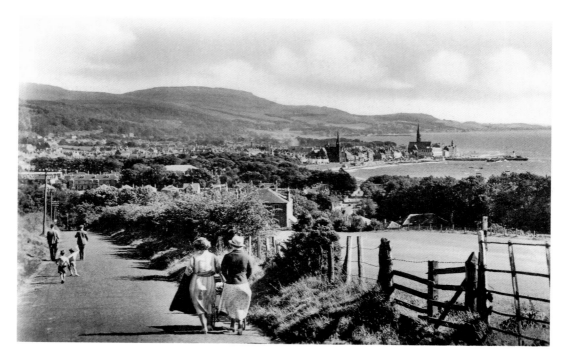

Red Road/Routenburn Road

This 1953 view is captioned 'from the Red Road', though the name now seems to have fallen out of use, since the road past the golf course is marked on modern maps as Routenburn Road. From the original viewpoint, the view in summer is now obscured by foliage, so a partial view is only possible from this angle in winter. This modern view shows the remnants of the late snows of 2013.

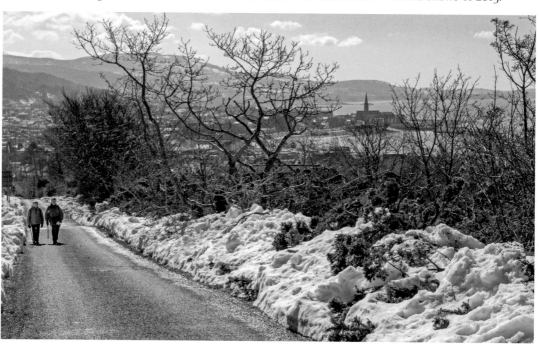

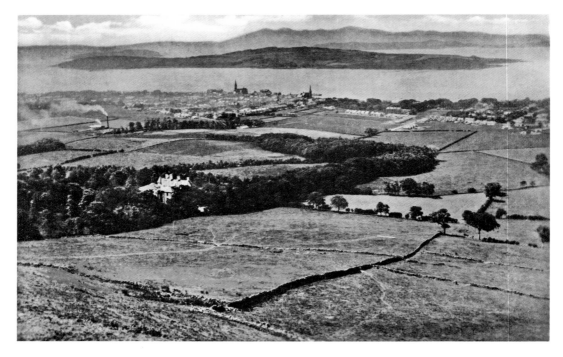

View from Above

A vantage point on the slopes to the north-east affords a view over the town towards Great Cumbrae, Little Cumbrae and beyond, to the Isle of Arran. Much has changed since this early picture was taken, possibly sometime around 1950. The building visible towards the left is the Hills Hotel. In 1957, this became the Inverclyde National Sports Training Centre.

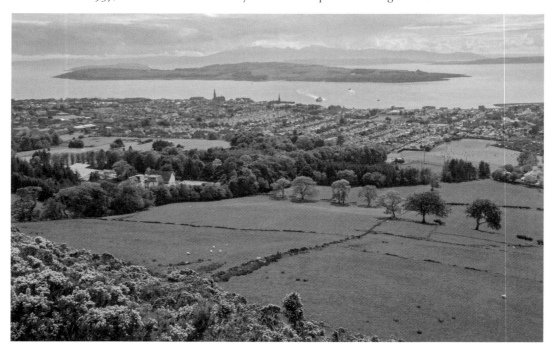

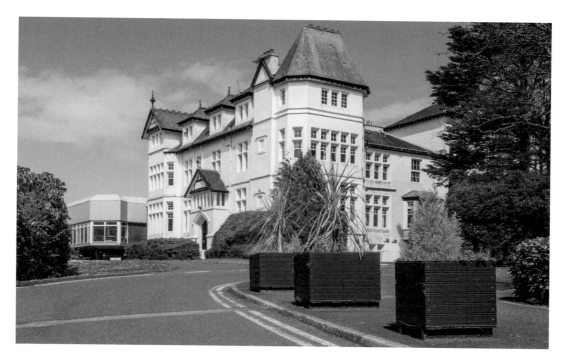

Inverclyde Sports Centre/Hills Hotel

On the slopes behind the town, Scotland's national sports centre sits in 70 acres of land dedicated to training fields for various activities. Among the modern facilities, however, sits an older and more attractive structure – the former Hills Hotel. Unaltered, except for the removal of some chimney-heads, this building retains its elegance.

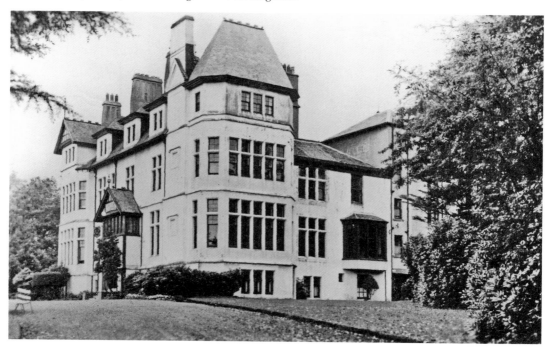

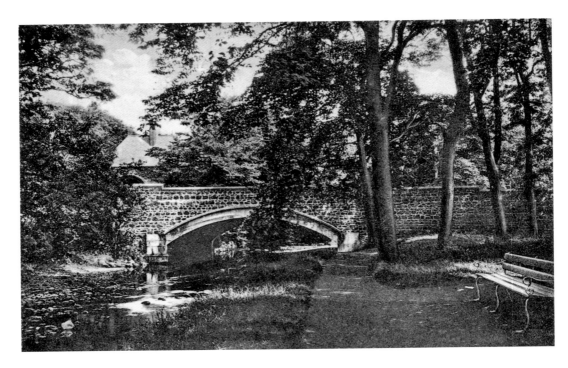

Noddle Bridge

Near the lodge marking the original entrance to Netherhall, a bridge carries the main road across the Noddle Burn. Sadly, the picturesque arched structure that existed in the 1930s, when this early picture was taken, has been substituted for a rather unattractive replacement, robust enough to support modern traffic but devoid of architectural merit.

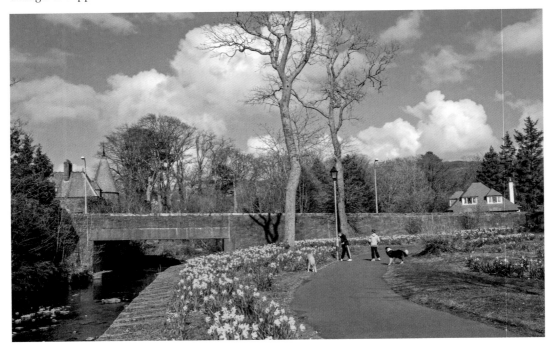

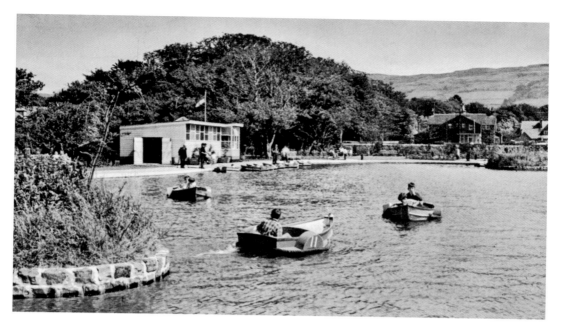

Aubery Lake

This artificial pond at the northern end of the esplanade, near where the Noddle Burn joins the sea, still exists, though the paddle boats seen in a 1960s picture are gone. However, vessels continue to ply its waters when local enthusiasts bring out their radio-controlled models.

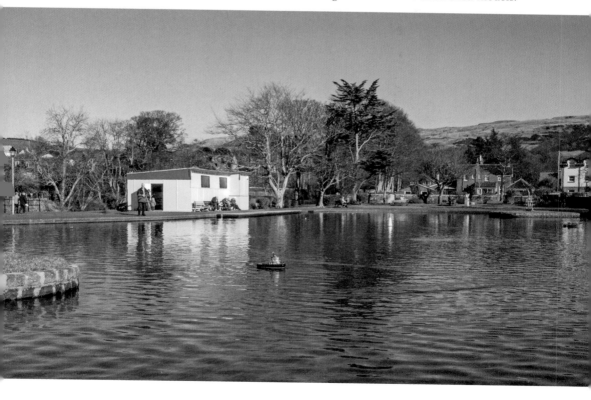

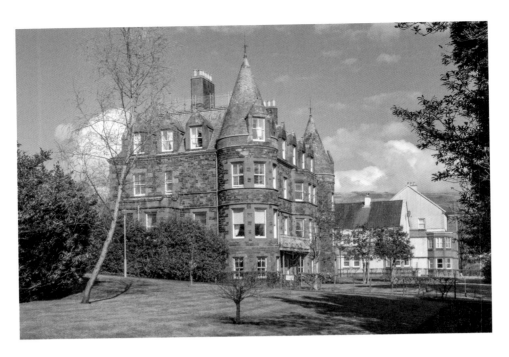

Netherhall

This impressive edifice was constructed in 1876 for William Thomson, Lord Kelvin – famous physicist and engineer, who worked on the laying of the first transatlantic telegraph cable and who gave his name to the temperature scale that continues in use today. The exterior remains almost unaltered from the original, though the interior has now been converted into apartments. When the picture of croquet-playing on the lawn was taken in the 1950s, the building was functioning as a hotel.

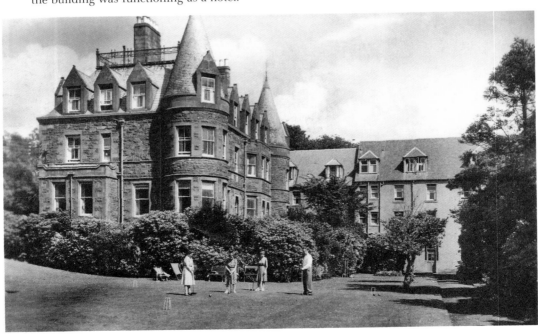

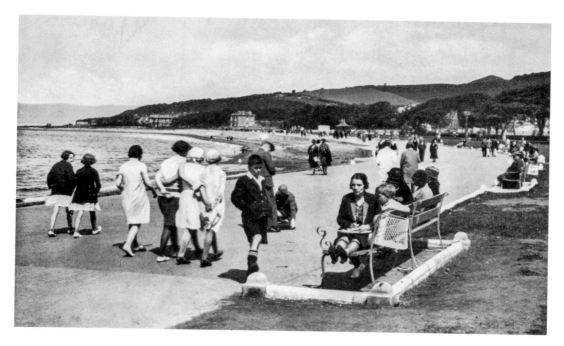

Victoria Promenade Looking North

Curving gently north from the pierhead is the northern esplanade, which runs for nearly a kilometre along the foreshore to where the Noddle Burn (Noddsdale Water) joins the sea at Aubery. A view along this promenade in 1933 reveals only a few isolated residences at the northern end of Largs Bay. A similar, slightly wider present-day view shows the same area now fully developed. In the distance, the summit of Knock Hill can be seen.

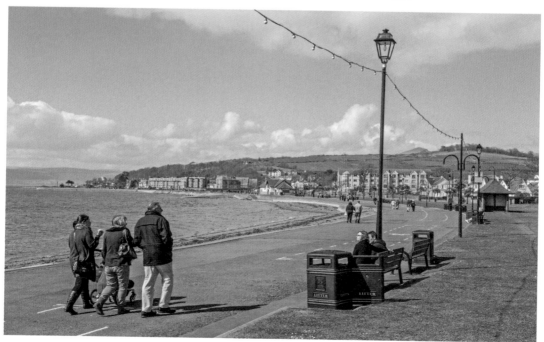

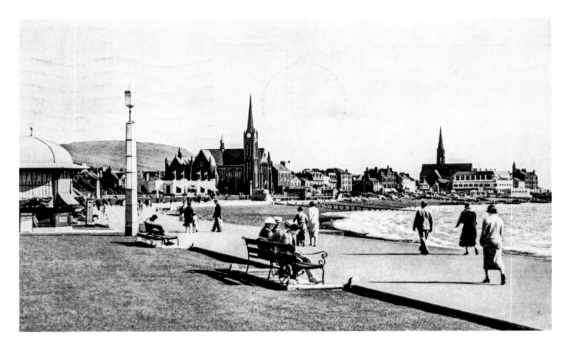

Victoria Promenade Looking South

A 1950s view along the northern esplanade shows a kiosk on the left similar to that which still stands by the southern esplanade. This one, however, has been replaced by the lifeboat station. The area adjacent to this section of the esplanade is marked on old maps as Noddsdale Green. Today, though the name may have fallen into disuse, the area remains open, unlike Largs Green, the part closer to the town, much of which has disappeared under the car park.

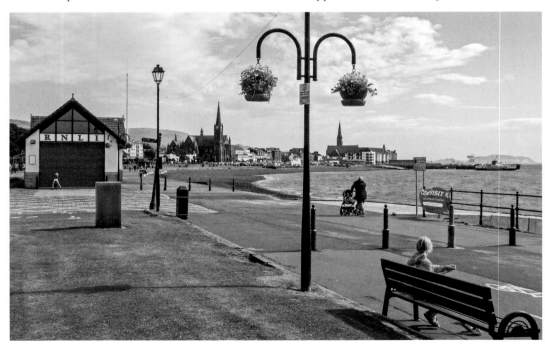

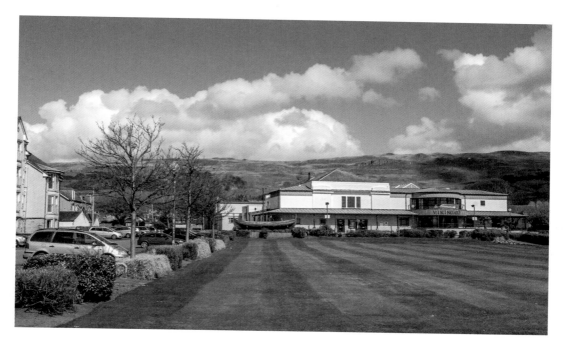

Barrfields Pavilion/Leisure Centre

Today, facilities in this building, which was refurbished and expanded in 1995, comprise the Barrfields Theatre and the Vikingar Pool. The theatre can now seat an audience of 500, reduced from its former capacity of over 1,000. Barrfields Pavilion, which was gifted to the town by Robert Barr in 1929, opened in 1930 and an early view shows it in its original form. During the Second World War, the building became the maintenance depot for the flying-boat squadron based at Largs.

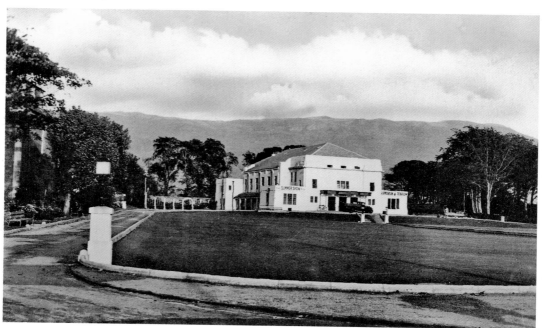

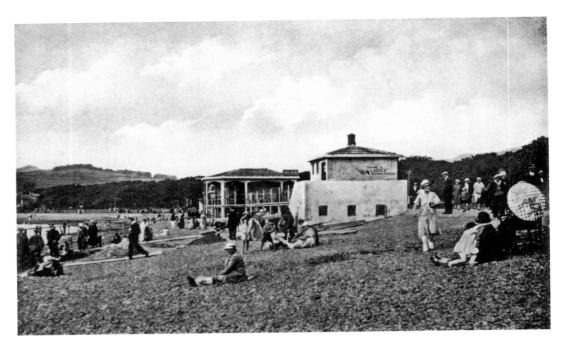

Bathing Station

In 1931, a bathing pavilion complete with changing rooms was constructed on the northern foreshore beside what was then known as Largs Green and has now become a parking area. During the 1950s, the building ceased to be used for its original purpose and by the 1960s housed only a small menagerie and aquarium. In 1967, the local council voted to demolish the aging concrete structure and its approximate location is now occupied by a small children's funfair. *Inset*: The station in the late 1940s.

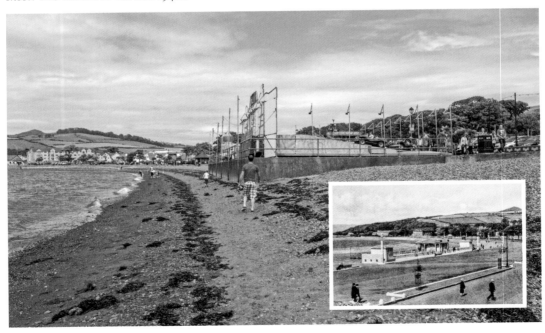

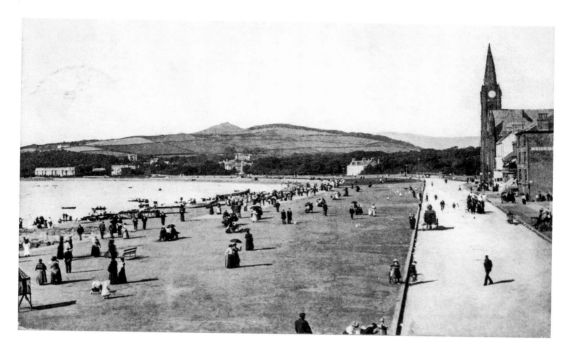

Largs Front

A 1906 view looks north along what was then known as Largs Green. Today, an elevated view of what is now the car park area is difficult to achieve, but even a street-level view from the pierhead junction illustrates the total transformation that has taken place here. The area is now so cluttered that this is the only position from where a view along Gallowgate Street, from a similar angle, is possible.

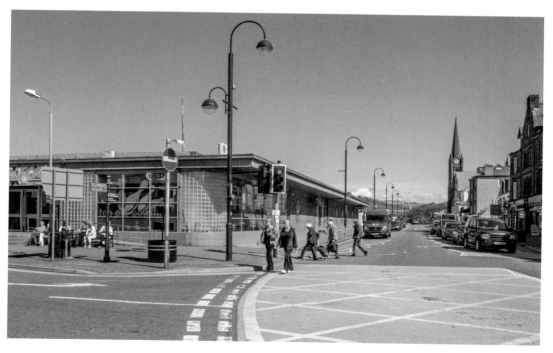

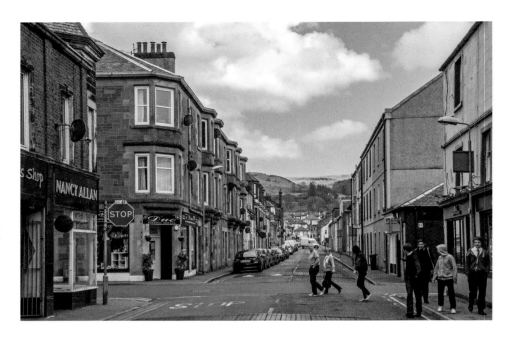

Nelson Street

Building in this area began in the early nineteenth century, to provide accommodation for weavers during the boom time for hand-weaving. By 1906, however, mechanical looms had taken over and the Nelson Street houses were then rented to summer holidaymakers. Today, the buildings look little changed from 1910, though new construction is much in evidence on the hillside beyond.

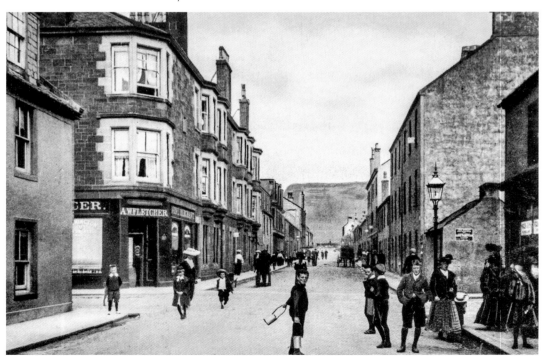

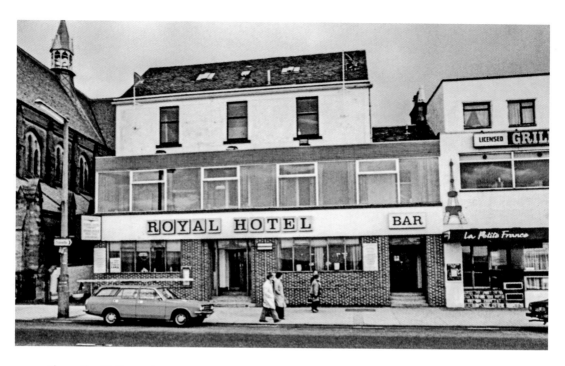

Along the Gallowgate

A picture dating from the 1970s shows a few of the businesses that operated on Gallowgate Street. Though the premises themselves remain, with some slight modifications, ownership has changed in the interim. La Petite France was put up for sale in 1979 and the Royal Hotel went into liquidation in 1984.

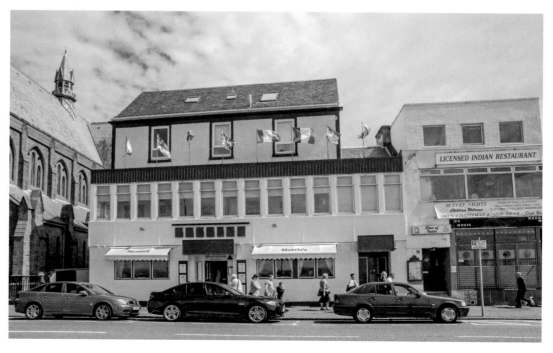

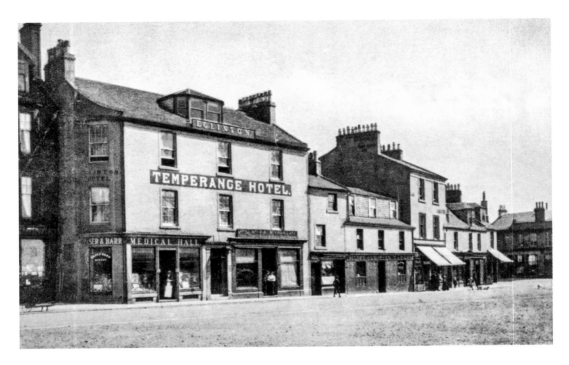

Gallowgate

An early view of the southern end of Gallowgate Street, where it approaches the pierhead, dating from 1906, shows the Temperance Hotel. Along with an adjacent building, the hotel is long gone and its site is now occupied by a modern building. The nearby building at the left has survived, however, as have those near the traffic lights at the pierhead.

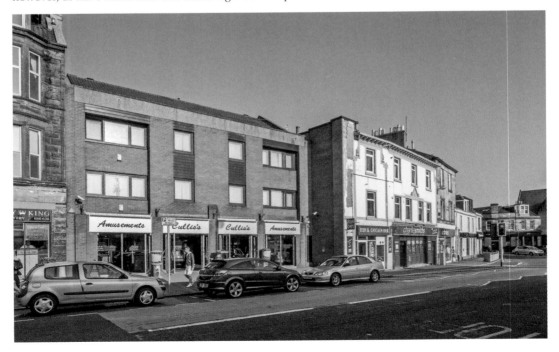

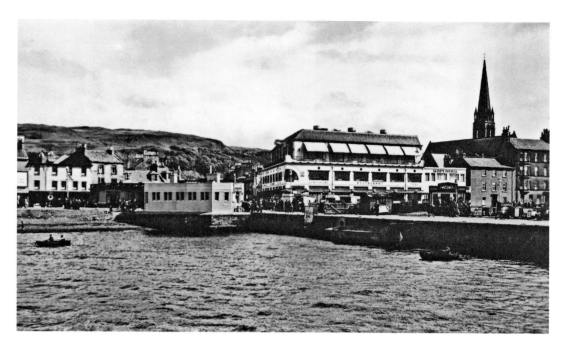

The Pierhead

In the late 1930s, this is how the pierhead looked when viewed from the outer section of the pier. Today, it looks completely different, with the corner now being occupied by the concrete ramp for the roll-on roll-off Cumbrae ferry, allowing a clear view through to Main Street. The Moorings is now hidden by the ticket office occupying the inner end of the pier, but the apartments above are clearly visible.

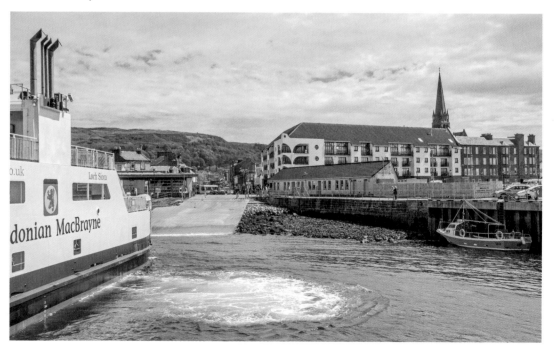

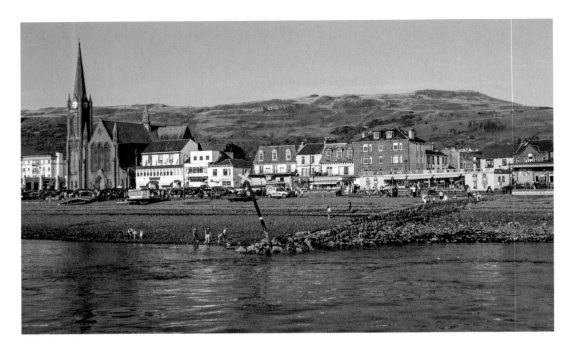

From the Pier

A modern view shows the shore about as busy as it ever gets, even on a summer's day, as few people now take to the water. An early view from the pier shows the shoreline busy with boating activity, of which there is very little today. The picture dates from no later than 1918, at which time building had yet to take place on the seaward side of the Gallowgate, where a row of commercial premises now exists.

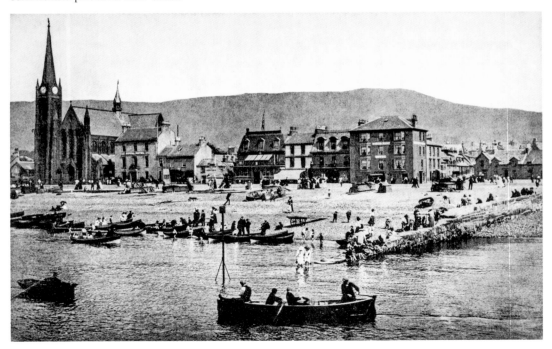

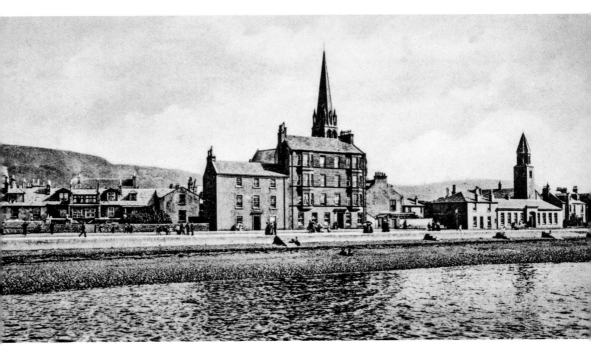

Fort Street from the Pier

South of the pierhead, this short street, which soon joins Bath Street, runs adjacent to the start of the southern esplanade. An early view from 1907 shows that a shingle beach, similar to that alongside the northern esplanade, once existed here. In the past, this area has been susceptible to flooding, so a fortified sea wall has now been constructed.

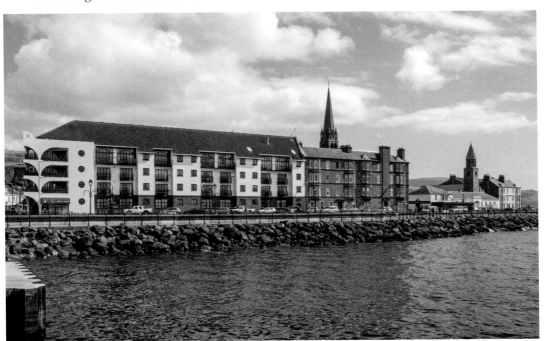

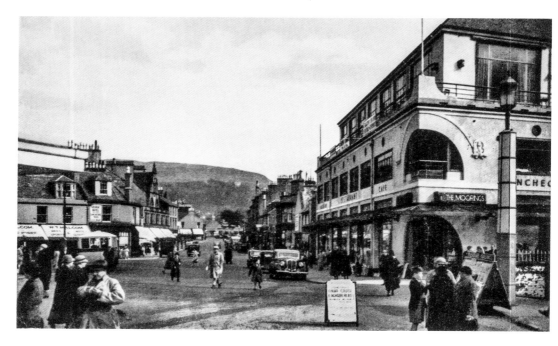

The Moorings

In 1936, this café and restaurant, which had its own ice-cream factory and bakery, was opened on the seafront. In keeping with its location, this had a distinctive nautical design, with porthole windows and a cutaway corner simulating a ship's bow. The steel frame of the building, shown in a 1940s picture, was damaged by flooding in the late 1980s and it has since been rebuilt with an apartment complex above.

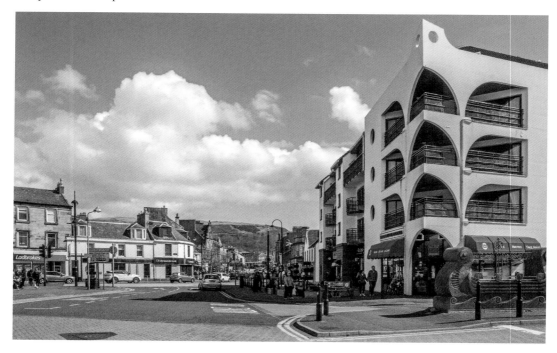

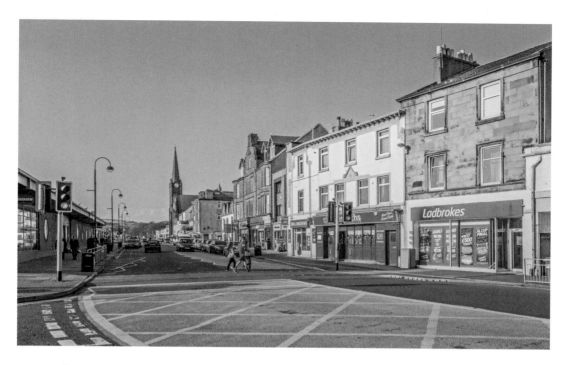

Gallowgate/Pierhead Junction

A present-day view north from the pierhead shows development on both sides of Gallowgate Street. In contrast, in a 1906 view, construction has yet to take place on the esplanade side. On the landward side, several of the buildings are recognisably those that stood there over a hundred years ago.

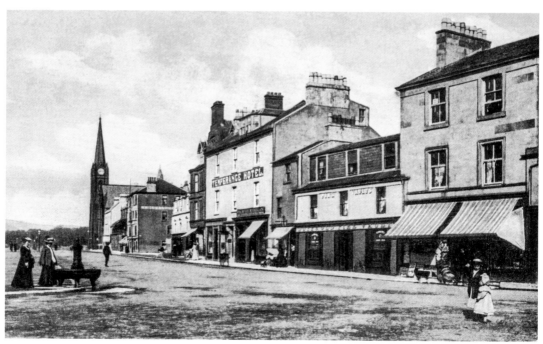

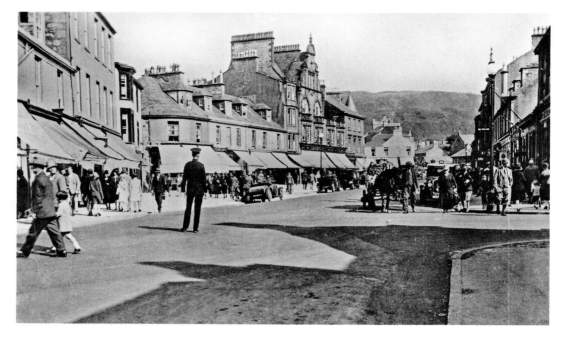

Looking East Along Main Street

The style of vehicle in this early picture suggests it was taken sometime during the 1930s. A view from the same point today, near the junction with Bath Street, reveals that, apart from cosmetic changes, the building infrastructure in this part of town has changed very little. However, the same cannot be said for the traffic conditions, so taking a position in the middle of the road would now be ill-advised.

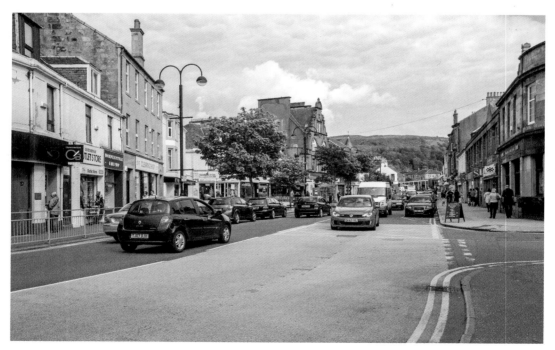

Main Street/Tron Place

The buildings in this part of town have stood for more than a century. The elegant building on the corner of Bellman's Close originally housed Largs post office, which was opened there in 1906. A view in 1910 clearly shows the building in its former role. It is now much modified at street level and its arched windows have long gone.

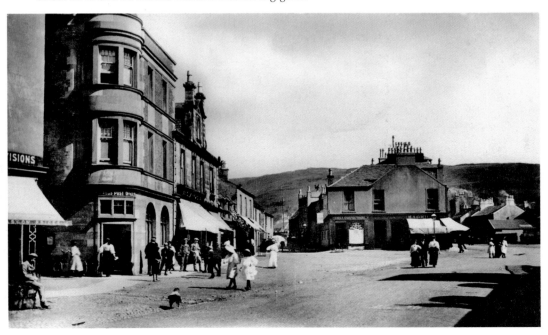

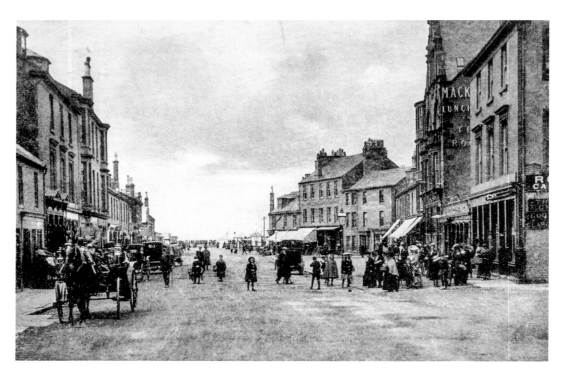

Looking West Along Main Street

This early picture shows how a view towards the pierhead would have looked before the First World War. A hundred years on, most of the buildings still stand, including those on the right, now hidden by trees. On the far left, however, beyond the Bath Street junction, change has taken place.

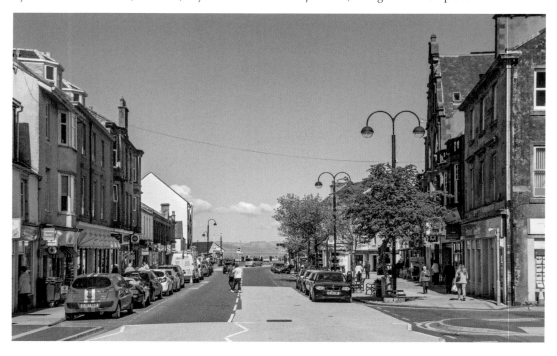

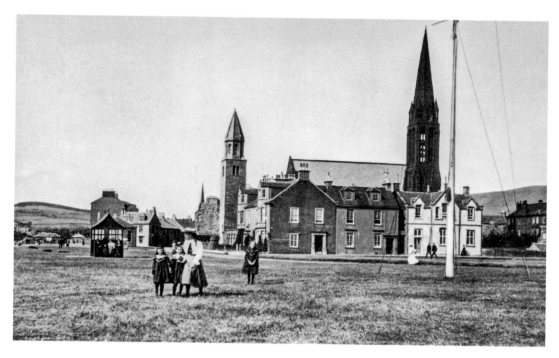

Bath Street/Union Street

This area just to the south of the town centre has remained relatively unchanged since this picture was taken around 1920. A new building has appeared on the right, but the others seem original, though the one in the centre of the picture has been altered and has had an extra storey added at some point. The original circular bath house, which gave the street its name, survives.

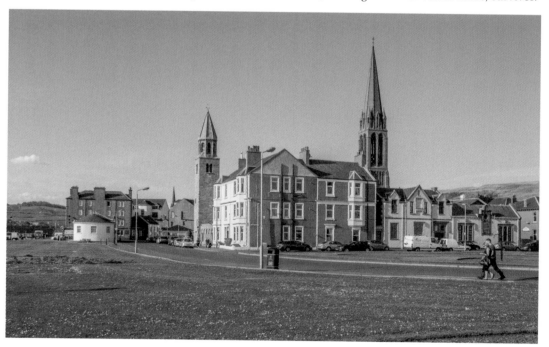

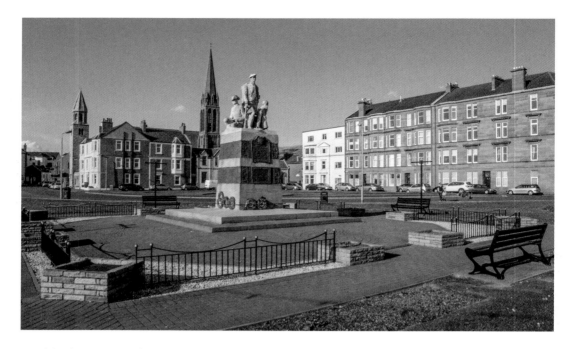

Sandringham Terrace/War Memorial

The red sandstone block on the right is considered to be one of the town's historic, landmark buildings. These centrally located seafront apartments, overlooking the memorial on the other side of Bath Street, command stunning views across the Firth of Clyde. An earlier equivalent view, probably from the 1950s, shows there has been little change in the area, save for cosmetic changes to some of the buildings.

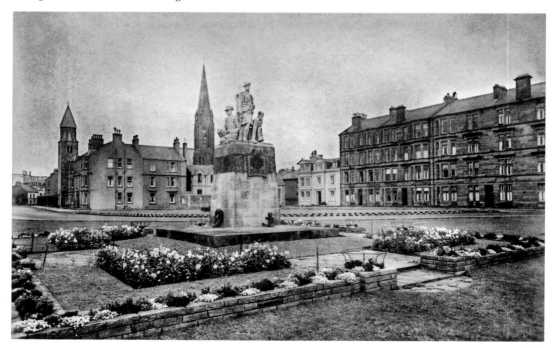

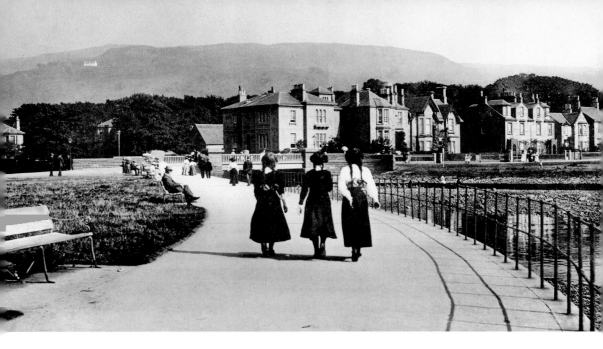

South Esplanade

The above picture dates to 1913, so these two images of the promenade, where it curves towards the bridge over the Gogo Burn, are separated in time by exactly 100 years. Several of the buildings that appear in the early view have survived the century, though they are now surrounded by later constructions. Both pictures also show the landmark Cock-ma-lane Cottage high on the side of Castle Hill.

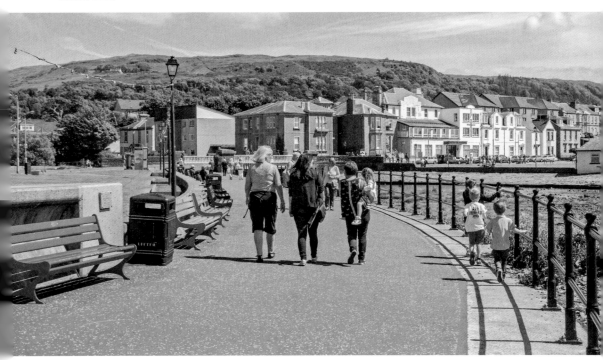

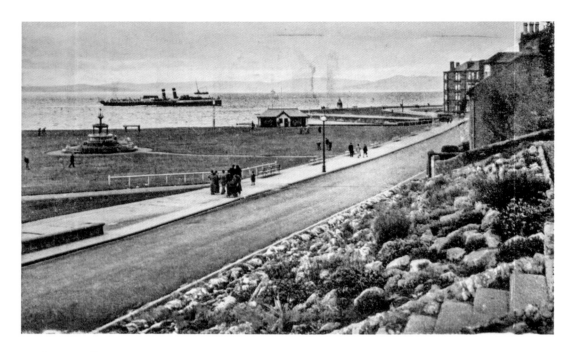

Mackerston Place

This view of the putting green and fountain dates to around 1950. This point, where the Gogo Burn enters the sea, is at the northern end of the Broomfields, which extends about half a mile south from here, round Castle Bay. The area was gifted to the town by Sir Thomas Brisbane, a nineteenth-century astronomer and colonial administrator, who owned the estate on which much of Largs is built.

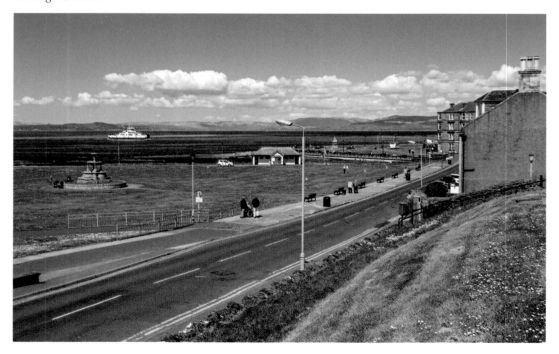

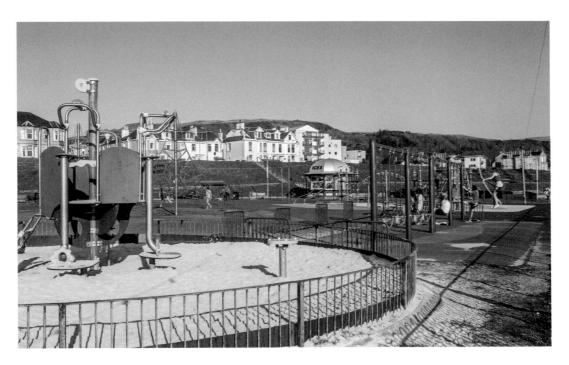

Play Park/Broomfield Place

This location, opposite the end of Charles Street, has changed almost beyond recognition. The ice-cream kiosk and some surviving residences in the distance confirm the correct alignment with the equivalent view from the 1950s. Though the purpose of the area remains recreational, the yachting pond has been replaced by a sandpit and play area.

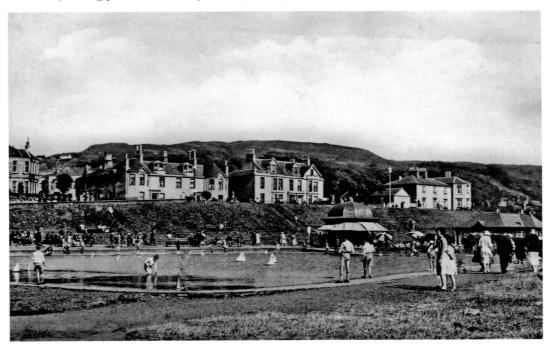

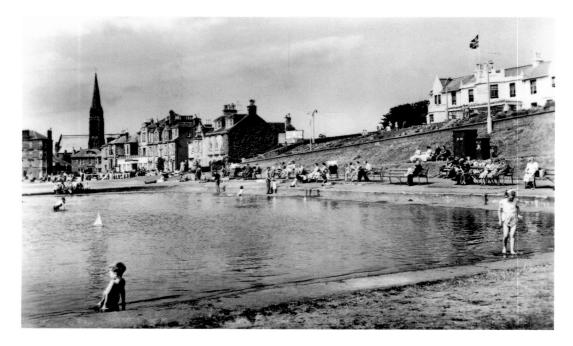

Yachting Pond/Activity Area

In a picture of the northern end of the Broomfields, dating from about 1960, the yachting pond sits below the Castle Hotel (*top-right*). The present-day view shows that neither of these has survived – the hotel was demolished only recently (around 2010), to be replaced by a bland modern apartment block, and the all-weather surface of the play park now covers the area where the waters of the pond once rippled. *Inset*: The pond from the north side.

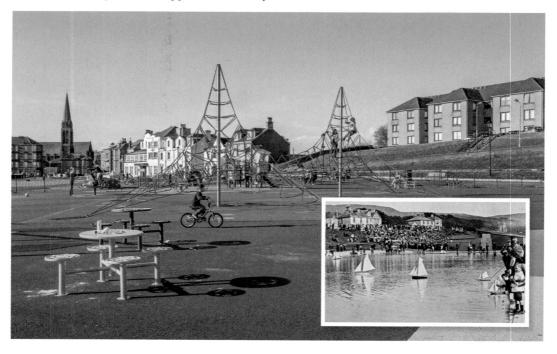

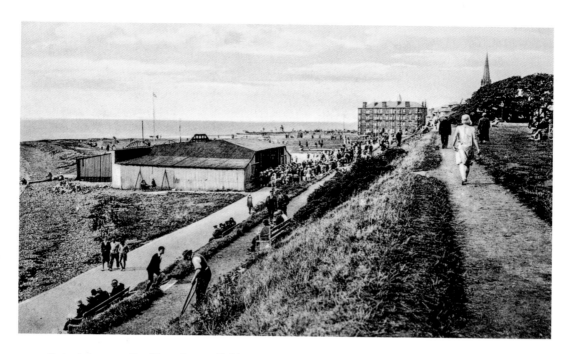

Entertainment Pavilion, Broomfields

An early view along the 'Lang Bank' around 1925 shows a small theatre and tiered viewing area. This was the pavilion where the 'Smart Set Cadets' entertained holidaymakers from 1916 onwards. Initially, a temporary stage had to be erected each year, but a permanent building was later allowed. No regular events take place today, but a Gala Day march-past by a pipe band provides some 'one-off' entertainment.

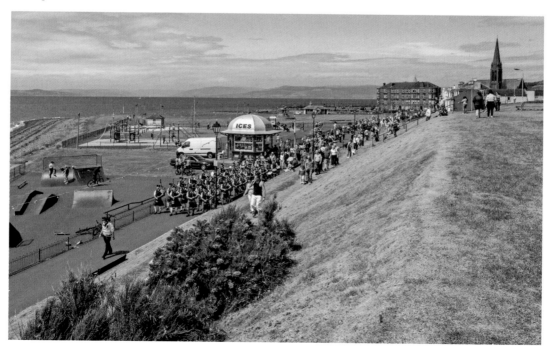

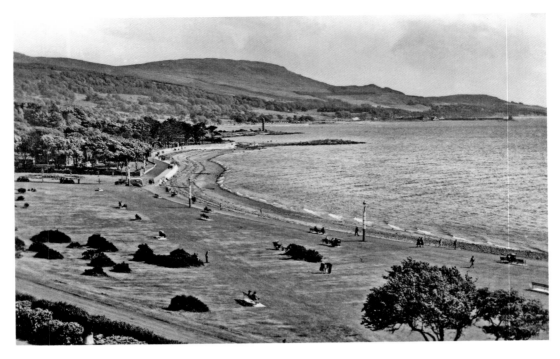

The Broomfields & Castle Bay

This old picture probably dates to the 1950s, since when much of the broom that gave this area its name has disappeared. A modern view, though from a slightly lower elevation, would be fairly uninteresting, but for the colour added by the tents set up by a Celtic re-enactment society for a promotional event.

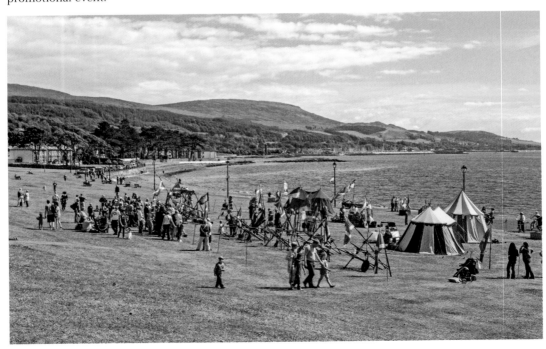

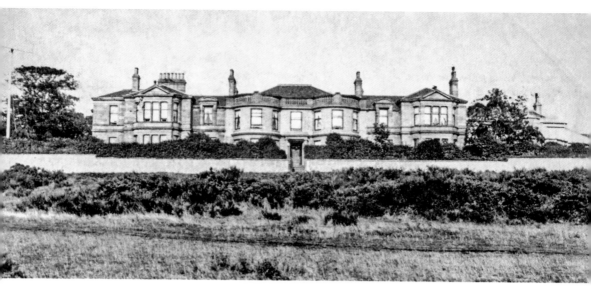

Curling Hall

An old picture shows this mansion house in 1903. It had been built by Doctor John Cairnie and was the site of the first artificial curling pond in Scotland. It later became a hotel that was subsequently amalgamated with an adjoining hotel to form the Marine & Curlinghall. During the 1960s and 1970s, this was famous for its dinner dances, which could cater for up to 600 people. Sadly, the buildings were demolished in 1983 and the site is now occupied by an apartment complex.

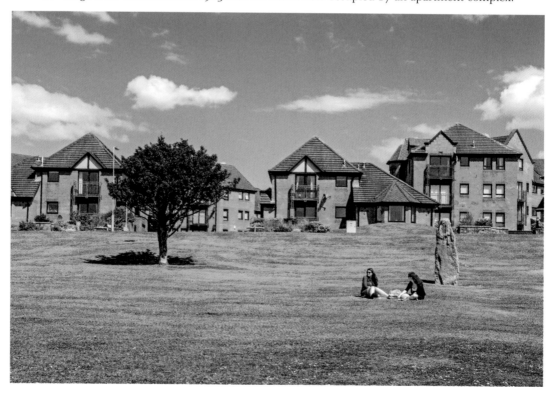

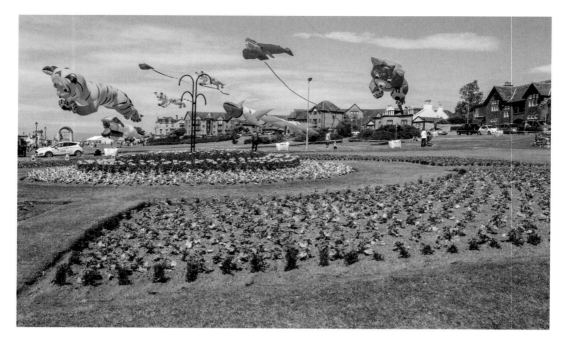

Broomfields Crescent

This present-day view across the garden area at the southern end of the Broomfields is enhanced by the presence of exotic kites being flown on Gala Day. The view is slightly wider than that dating from 1950, but comparison shows that the two dwellings on the right and the one on the far left still exist. In between, however, the apartments that replaced the Marine & Curlinghall Hotel may be seen.

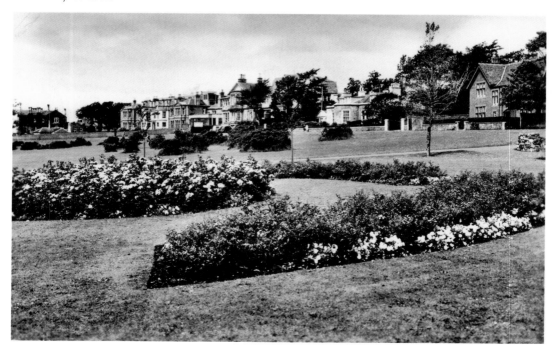

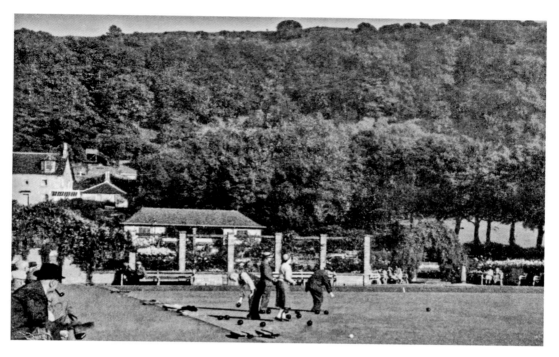

Douglas Park
This was gifted to the town in 1920 and this picture of its bowling green dates to the early 1950s. Today, the scene is little changed, but for growth in the vegetation and a change of fashion. Council cutbacks, however, have meant that the gardens visible beyond the green are perhaps not as well tended as they once were.

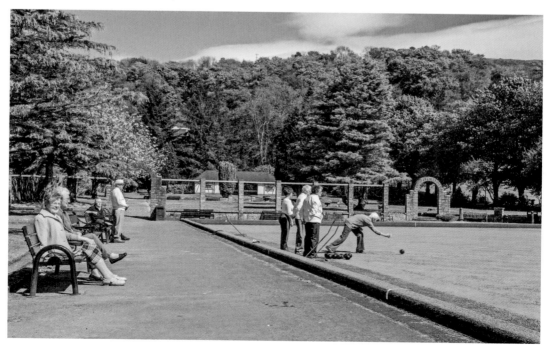

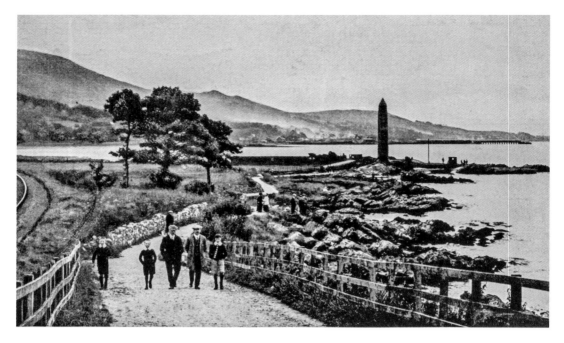

View South Along Bowen Craig Walk

This walkway is an extension of the southern esplanade all the way out to the Battle of Largs monument – a Celtic round tower erected in 1912 to commemorate victory over the Vikings in 1263. Apart from the refurbishment of the path itself, the most obvious change in this area is the building of the marina visible to the south of 'The Pencil' – the Largs Yacht Haven.

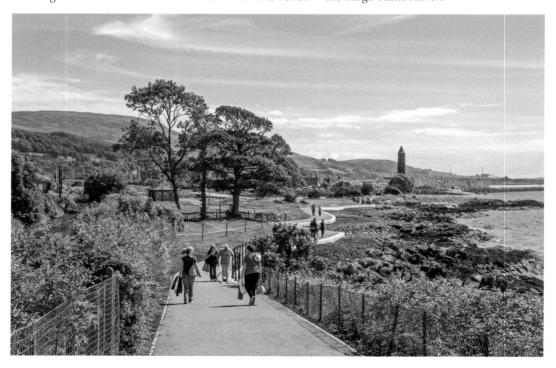

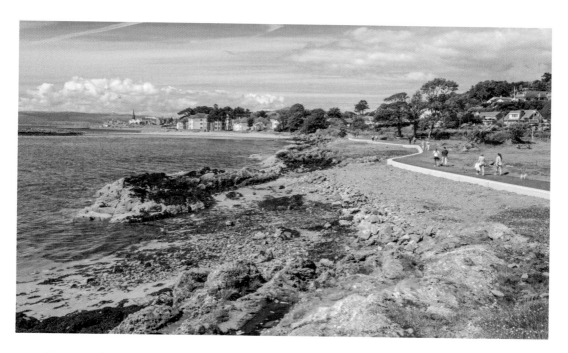

View North Along Bowen Craig Walk

A present-day view looking towards the town from near 'The Pencil' shows numerous apartment complexes adjacent to the water's edge and a walkway that has recently been completely relaid (in 2013). In contrast, in an early view, possibly dating from the 1940s, very little exists, other than the walkway itself, in the area between the railway line and the foreshore. The rocks, of course, remain.

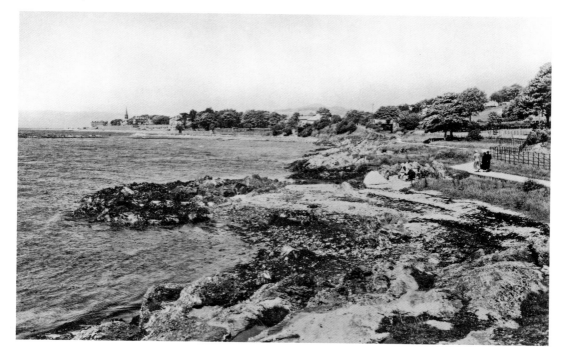

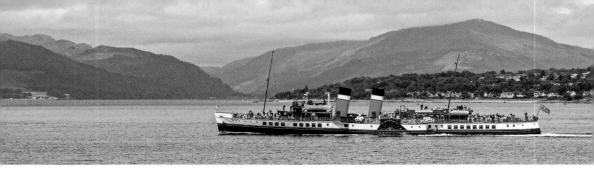

Echo of the Past

As *Waverley* passes on her way 'doon the watter', with Kilcreggan and the Argyll Hills as a backdrop, she provides an opportunity to visualise how the river once looked. It is an incredible cultural bonus that she still survives to reflect a bygone age, when the pace of life was slower and vessels had an elegance that seems to have been lost.

Acknowledgements

Images of earlier times are most readily available as old picture postcards, so this is the medium from which most of the early pictures have been reproduced, though some have been scanned from a century-old picture book of Inverkip, publisher unknown.

A few images are by courtesy of the McLean Museum archive (thanks to Val Boa). These appear on pages 8, 13 and 47.

Special thanks to Mary Harkness for allowing access to the foreshore to enable the picture on page 40 to be taken.

All the present-day photographs are the work of the author.

References

Milne, Colin, *The History of Gourock 1858–1958*
Alan Godfrey Maps, *Largs 1895 & Wemyss Bay 1912*
Undiscovered Scotland website (www.undiscoveredscotland.co.uk)
Inverkip website (www.inverkip.com)
Wemyss Bay website (www.wemyssbay.com)

The Author

Born in Fraserburgh in 1947, Bill moved to Inverclyde in 1970, after graduating from Aberdeen University with a degree in Science. He worked for IBM, in computer software support, for over thirty years before retiring in 2001. He obtained his first camera, a Brownie 127, around 1961, which initiated a lifelong interest in photography. He has been an active member of Inverclyde Camera Club for many years and still maintains a keen interest in the hobby. He was co-author, with Gaie Brown, of a previous book in the series: *Greenock & Gourock Through Time*.